Douanier Rousseau

Modest Morariu

ABBEY LIBRARY
LONDON

Douanier

Rousseau

Translated from Romanian as published by
MERIDIANE PUBLISHING HOUSE
Bucharest, 1978
under the original title of
DOUANIER ROUSSEAU
by
MODEST MORARIU

Translated into English by
RICHARD HILLARD

ARTIST OF THE FUTURE

Embarking upon the study of Henri Rousseau Le Douanier, we are called upon not only to evoke the personality of a painter but rather to tackle the complex and contradictory debte on the value of his art, totally denied by some whilst enjoying the unlimited admiration of others. The same canvases, which roused the mocking hilarity of his contemporaries — deep-rooted in the artistic canons of their times and captives of their own conformist vision — today fetch staggering prices on the market of artistic values. The characteristic traits of his art, which at the time were the butt of mordant and even fierce criticism, came to be regarded as priceless stylistic qualities, thus vindicating the candid megalomaniac conviction of this humble excise-officer. His megalomania, initially born in self-defence, turned — as his critics gradually yielded under the force of his unswerving perseverance — into an unshatterable faith in his artistic creed. He first gained the goodwill of his fellow-artists when they discovered in this untutored amateur some astonishing craftsman's intuitions and then acquired the sympathy of a number of men of letters who regaled in weaving a fanciful legend around this picturesque personage. The supreme recognition of the ambiguous interest shown in Rousseau, the moment of crowning glory of this artist during his lifetime, was the famous banquet organized in his honour by Picasso in 1908. The spectacle must have been exceedingly savoury and the description of the party — though rather controversial in its details — represents a most vivid page in the history of the so colourful artistic Bohème of Paris in the first decades of this century.

Let's try and conjure up the picture, from the accounts of some of the participants:*

Picasso's studio at Bateau-Lavoir, where this party was held — a sort of large timber-framed shed — had been gaudily decorated with wreaths and garlands of flowers and Chinese lanterns; African masks adorned the walls, whilst at the place of honour, hung the portrait of Yadwiga *(Mademoiselle M.)*, painted by Rousseau. A chair perched on a wooden case was to be the throne of the fêted guest. Above the throne, on a long banderole was written in large block letters: *Honour to Rousseau*. The banquet table was merely a wide board set upon trestles. Azon, the caterer, had borrowed crockery, cheap tin cutlery and chairs for this occasion. Among the numerous guests were Apollinaire with Marie Laurencin, the poet Max Jacob, Braque, Maurice Raynal, the art critic, Fernande Olivier — Picasso's mistress at the time — as well as three art collectors who had come from New York, Hamburg and San Francisco. An electric organ enveloped this atmosphere of festal merriment in wavers of discordant music. The arrival of Rousseau in his soft felt hat, with his stick in his left hand and his violin in his right, promptly silenced the din. At the sight of the gayly decorated hall and the crowd of people gathered to honour him, the eyes of the old Douanier (who was accompanied by Apollinaire) lit up with pride and joy. At nine o'clock the repast was to be served. It was only after two hours of vain expectation, that the organisers realized that the dinner had been ordered for the next day at noon and then hastily improvised a supper with some rice cooked by Fernande after a Spanish recipe, completed with a few trifles they were able to purchase at the local grocer's and confectioner's. After the dinner, that had been lavishly washed down with wine, Rousseau played a composition of his own caled *Tinkling Bells*, followed by another named *Clemence*, a waltz this time, as the guests were anxious to dance. They were all in high spirits and the guest of honour seemed to be too entranced even to realize that drops of hot wax were trickling from a Chinese lantern upon the crown of his head, adorning it with a strange sort of glossy night-cap. He was in a state of ultimate bliss. Apollinaire then recited the poem dedicated to him on this occasion: "Remember, Rousseau, the Aztec landscape . . ." whereupon, midst the general clamour, Rousseau mumbled a toast. After a while he fell into a sweet slumber whence he would awake now and again and blissfully look around. At the break of dawn, he was driven home in a horse-carriage . . .

We need make no effort of fancy to picture the burlesque nature of this celebration, where a tone of kindly amused superiority mingled with the tender irony

* Maurice Raynal, Fernande Olivier and Antonina Vallentin

with which our hero was generally regarded. We very much doubt that any of his contemporaries, boastful of their own merits, undeniably of greater value, should have foreshadowed Rousseau's posthumous glory. Few indeed would ever admit — could such a question be posed to them today — that Rousseau was anything but a picturesque personage of their society rather than an artist who could claim lasting recognition.

The aestheticians have launched with great relish a new artistic notion labelled *Kitsch*, embracing in its sphere a number of singular or subartistic products, not devoid however of savour by their very denial of and contradiction with the current aesthetic tenets by which they were assessed. They infringe upon these canons either by their manifest bad taste or by their extravagance and oddity. *Kitsch* is one of the rages today; it is studied as a para-aesthetic phenomenon: scholarly tomes are being written upon it. Ultra-refined aestheticians cultivate the style and collect their products. In point of fact, we are witnessing a fairly old phenomenon which has now acquired a name and a criterion for its classification. Many years back, with what might be called 'leftist' frenzy, Rimbaud unwittingly defined the sphere of Kitsch when he asserted: "...I found the celebrities of modern poetry and painting lamentable. What I really enjoyed were idiotic paintings, set above house-doors, settings or curtains at country fairs, popular illustrations; old fashioned literature, the Latin recited by Church chanters, erotic stories with crude and freakish spelling, the romances sung by our grandfathers, fairy-tales, the story books of my childhood, the lyrics of old operas, silly ditties, naive lilting tunes." *(One Season in Hades)*. Poor Courteline, having bought for his 'horror-museum' the *Portrait of Pierre Loti* (so-called), painted by Rousseau was irretrievably compromised in the eyes of all genuine art-lovers who branded him a philistine for his inability to recognize a true genius. It would be interesting to know how many of those who value Rousseau's work highly today would not have laughed or mocked at his art at the time. * It is hard to believe that when Rémy de Gourmont the aesthetician published in 'L'Ymagier' *Images and Studies on Old and New Images and Image-makers* and among them the lithograph *The War*, he regarded Le Douanier's art as being more than an unwonted form of picturesqueness.

Some less versed contemporaries vehemently denied his artistic value with sweeping conceit. Thus an art critic declared pompously: "*Henri Rousseau appears to be highly appreciated in Germany and in Russia. Quite possible. But we fortunately live in France and are French.*" ** In point of fact, for the art connoisseurs of his time, Henri Rousseau was no more than an author of Kitsch painting, ridiculous to some, interesting as an oddity to others, loved for his good nature and candour, pathetic for the perseverance with which he fancied himself an artist, something they never recognized him to be. The Impressionists and Post-Impressionists were regarded as heretics; yet no one contested their professional status. A status that was totally denied to Rousseau. What he was recognized to possess was at most some flashes of artistry such as the inimitable black pigments, which Gauguin is said to have remarked, or a certain kinship with the European Primitivists *** (which statement was not necessarily a commendation) or with the Animal Style painters of Persian miniatures. ****

* Apollinaire's interest in Rousseau and the almost legendary appreciation of his art led all commentators to associate the names of the two artists, lauding the great intuition of the poet in recognizing the painter's genius. And yet his enthusiasm was not quite as unmitigated as it was credited to be, to judge by the very words written by A p o l l i n a i r e in 1908 in the 'Revue des Lettres et des Arts' (quoted by H. C e r t i g n y): "*Rousseau's exhibition is both moving and humorous. This self-educated artist possesses undeniable natural qualities; Gauguin is said to have admired Rousseau's black colours. On the other hand, Le Douanier is too destitute of general culture. One cannot fully trust his ingenuousness. Hazard and even ridicule are conspicuous in his work. Henri Rousseau knows not what he wants nor whither he is heading for ... Rousseau is no more than an artisan.*"

As to J a r r y's frank opinion, expressed with compassion, we may quote the critic's own words, published in 'La Revue Blanche', on April 15, 1902: "*... How powerful, not to say astute, these people are*", writes the latter. "*Here we are faced with unqualified and ignorant people, painting with candour and pathos these heart-rending horrors, which would make a schoolboy blush. Here is Henri Rousseau, the legendary master: if he only had the gift of painting and were able to draw, his ardour and ingenuousness would make him a genius.*" (Ap. H. C e r t i g n y).

** quoted by Antonina Vallentin in the monograph *Picasso*, without giving the name of the critic.

*** "*Among those worthy of mention in particular is Mr. Henri Rousseau whose unappeasable naïvety rises to a sort of style and whose ingenuous headstrong simplicity has the merit of calling to mind — with no other sentiment than tolerant goodwill (sic !) — the works of certain Primitive painters. His pathetic lack of craftsmanship ...*" (T a d é e N a t a n s o n, in 'La Revue Blanche', 15 June 1897).

**** "*In the fight between the lion and the antelope painted by Mr. Rousseau, we recognize an old Oriental theme which the Chaldeans passed on to the Persians, and which the European art of the Middle Ages did not ignore ...*" (F o u r c a u d, in 'Le Gaulois', 17 October 1905).

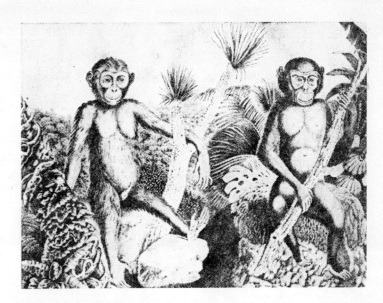

Some comparisons went farther back to the primordial artists of cave paintings*. At the Salon of 1888, Degas, exasperated by some bore who wanted the artist's opinion about the new trends in art, pointed at random to a canvas that happened to be Rousseau's: "Who knows whether this will not be the painter of the future?" Would anyone interpret these words as a token of genuine appreciation?

The only artists who with unflagging conviction believed, from the very outset, in the genius of Henri Rousseau were in the first place the generous Wilhelm Uhde and then, with great professional insight, the Italian painter Ardengo Soffici. Uhde realized that the work of Le Douanier was an artistic miracle, born outside that dialectic process from which the historical styles of art emerge. He includes him too among *the pure-hearted painters blessed with grace he celebrated.* In point of fact he is the first artist who officially introduced naïve painting in the history of arts, securing its right of citizenship alongside cultivated art.

BETWEEN KITSCH AND THE GRAIL

In its relation to the historical styles, naïve art constitutes a breakthrough and a novelty. It naturally existed throughout the ages, practiced at the fringes of cultivated art, generally ignored by the latter or classed as folk art. By virtue of his unique talent, aided also by a felicitous artistic climate, Rousseau was the first to defeat this anonimity, establishing not only his own reputation but also this genre of art. An art, industrialized in some parts, which, proliferating at a dazzling pace, finally contaminated cultivated art. Kitsch has become a fashion! Educated artists mimic the inexpertness of the naïve. It is not these however who are convincing; their ventures testify only to the crisis prevalent in the arts of our epoch. A crisis that, moving along another channel, has led to various mannerisms grounded upon the most diverse theoretical claims. The result — a total failure: since the first condition for the practice of naïve art is not to wilfully aim at being naïve, but rather to possess that spiritual quality, compounded of candour, simplicity and emotionalism (but not sentimentalism). He who enjoyed the privilege of seeing the Holy Grail — the vessel in which, according to the legend, Joseph of Arimathea had collected the blood which flowed from the wounds of Christ upon the cross — was not the bold and wise Arthur but Parsifal, the knight blessed with grace. *Rousseau the God Blessed!* exclaimed a critic (L. de Beaumont) beholding his pictures. And indeed, in the sense of the Gospel Rousseau *was* 'blessed with grace'.

That naïve art has emerged from Kitsch is a hypothesis we venture to put forward. What we admire in this genus is its very unconformity with the established canons of art. Not a deliberate denial of its rules, for the naïve ignores all models and aspirations pursued in established art. If we admit that the classical ideal

* "...*Providence endowed him with a special mentality, akin to that of the Primitive artists who designed heads of aurochs on cave walls. Let us hope he will have no disciples; we must however recognize his frankness as well as an instinct for pure colour which is undeniably meritorious...*" ('L'Evénement', 18 October 1905).

of beauty can degenerate into Academism — which is but scholarly Kitsch, denaturating not its forms but far worse, its instrinsic and ideal substance — why then deny the possibility of Kitsch becoming genuine art when expressed by a great instinctive power of creation uncorrupted by instruction or culture? Thus, paradoxically, it is the very failings of the artist that generate and impose new stylistic forms ! This is all the more credible since the reverse process is oft recorded: when producers of naïve art land in Kitsch.

Rousseau's ideal — though Mr. Clément kept urging him to remain a naïve — was Academic art, the art of Mr. Clément, Bouguereau and the others of the same school. These were the artists he admired and whom he struggled to emulate; failing to attain their craftsmanship, he paradoxically became the unique Rousseau, surpassing them by those very traits that distinguished him from them, and which in their company, engendered his inferiority complex.

Extracultural and heterogeneous, the limits of naïve art cannot be easily determined. Naïve is also the art produced by children and the insane. There are naïve artists totally isolated from one another and oblivious of the official artistic movement, there are others at the fringes of cultivated art which they strive to mimic, finally there are organized schools, such as that of the Yugoslav naïves. To the same sphere belong also the productions of some amateurs, steady or accidental contributors, pertaining to the most diverse milieus, gathered since 1945 by Jean Dubuffet, in the so-called group of Raw Art. What criteria could be adopted to define the scope and limits of naïve art? One criterion could be professionalism. The drawing of a child is definitely naïve art, but the child is not a professional but a spontaneous creator. The same holds true also for the products of psychotics.

*"Nous sentons pourtant que si l'enfant est souvent artiste, il n'est pas u n a r t i s t e. Car son talent le possède, et lui ne le possède pas. Son activité est distincte de celle de l'artiste en ce que l'artiste entend ne rien perdre, ce que l'enfant ne cherche jamais (...)." "...Or l'art n'est pas rêves, mais possession des rêves.".**

The artist mastering his dreams endows them with a personal, coherent and unmistakable form, a *style.* Style implies elaboration, hence what distinguishes a naïve amateur from a naïve professional is the fact that the work of the latter is the product of an elaboration, which presupposes the consciousness of possessing the means enabling him to assert a personal and recognizable vision, defining his specific style. *"My work,"* declared Rousseau, *"is said not to belong to this century. You will understand, I trust, that I cannot change my manner, for it is the result of long unbending efforts.".*

Suffice to set side by side the rough preparatory sketches of his pictures and the completed work, to realize the process of elaboration to which Rousseau subjected his paintings in order to impose his *manner.*

What fascinantes one in naïve art in general, and in Rousseau in particular, is the great power of transfiguration of reality into images of a miraculous world. The most striking feature common to most naïve artists is the fairy-like vision of the world. Is it an obscure search for compensation, a need to conjure up a catharctic Eden by the intermediacy of art? Quite possibly, if we retain the fact that most naïve artists are humble victims of the hardships of life; this applies also to the sordid life Rousseau was called upon to live. Without embarking upon any psychological speculations, we may confine ourselves to this unifying trait valid for most of the naïve artists.

The terminology applied in modern art criticism contains the notion of 'Magic Realism', coined by Franz Roh in 1925 in reviewing the stylistic Post-Expressionist trend of the New (or 'Honest') Objectivity *(Neue Sachlichkeit)* group. The scope of this notion has expanded: Magic Realism is interpreted as a flight from the temporal, the dream of a Lost Paradise where common reality regains its miraculous halo. Magic Realism is a dominant trait with practically all naïves and with Rousseau in particular, for all his themes are real and earthly. Only that, by means of his hand this reality is turned into a new identity. Commonplace themes, oft intrinsically vulgar and petty bourgeois, acquire an ineffable poetic charm, turning into poetry: Poetry ideally conceived as embracing and incorporating all Arts.

* "We realize however that even though a child may often be artistically gifted he is not *an artist.* For his talent masters him, whilst he does not master his talent. His work differs from that of an artist by the fact that the latter struggles to miss nothing, which the child never strives after (...)". "Art is not made up of dreams, but is the fruit of mastering dreams".

But the arts of our epoch tend to move away from poetry. The only place where we still find it is among the Impressionists: vigorous, intoxicating, sensuous, immanent but, for this very reason, restricting the flight of fancy. Still enamoured with the immediate reality, influenced by the champions of literary Naturalism, they strive to transfer it upon canvas, in that fleeting moment, imperceptible to the common eye. Monet's water-lilies, which herald Abstract Art, are admirable for their pictorial value; Rousseau's water-lilies, on the other hand, may well adorn the paradise of our dreams of the days of Genesis.

We cannot deny the poetic thrill extant in symbolic painting, the metaphysical claims of which set it at the pole opposite to the Impressionists' immanence, 'these parasites of the object' as Odilon Redon branded them. "*All my originality*," says Redon, "*resides in making imaginary creatures live like human beings, straining to invest the invisible with the logic of the visible.*" This deliberate theoretical claim, however, adulterates the purity of poetry with the artifices of intellectualism.

The effort of the Post-Impressionists to bring painting again closer to reality is also a *cosa mentale*. In their excessive cerebrality, they destroy the fusion between affectivity and intellect which ideally must rule true art—a fusion by which, employing Jean Grenier's felicitous observation, 'sentiments become deep-seated ideas'. Cézanne's ambition to re-create Poussin after nature, fettered his temperamental Romanticism to such an extent that it ended in a form of cold and calculated lyricism rendered by a Parnassian painter.

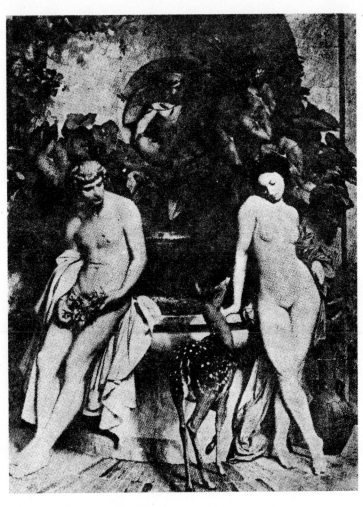

JEAN-LÉON GÉRÔME
Innocence.

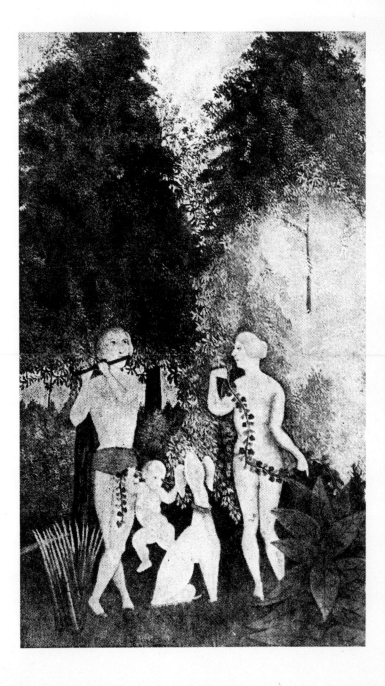

HENRI ROUSSEAU
The Happy Quartet

The science of our century has been working its way into the realm of arts. Seurat, Signac aimed at applying to painting the theories propounded by the physicists (Eugène Chevreul, David Sutter, O.N. Rood). Technical searchings threaten to pervert the soul of painting, for skill tends to replace feeling. Artists become theorists. A Heraclitic daemon seems to be constantly inciting a ceaseless innovating frenzy. The inevitable consequence is a saturation of intellectualism leading, by the natural play of dialectic equilibrium, to its very negation, Gauguin challenges it, but his denial is still an intellectual reaction, whereas Rousseau's contains no trace of wilful defiance but like Parsifal's is simply the fruit of transcendental inspiration. He restores painting to Poetry, even if, at times, in his excessive sentimentalism, it is merely a romance that he limns. Whence does he draw the ineffable charm and sincerity of his lyricism and the power of persuasion that fascinate the viewer, integrating him in the artist's fairy-like world? It is from Nature, the great seducer, the same nature his illustrious contemporaries were striving to conquer. But their approach was that of dour fighters, for between them and nature there constantly rose their own demiurgic vanity: their will to master and reshape nature, this possessive urge that only widened the gap. Whilst Douanier's naïve approach was an act of humility, wishing only to 'reproduce' nature. Nature in its eternal generosity, revealed unto him one of its infinite images: the one that the artist bore in his nature-loving heart.

ALONG A NEWLY-BLAZED TRAIL

Facing his books, long read and consumed, Mallarmé dreamed of an 'exotic nature', the blissful thrill of birds floating between the unfathomable sea and the heavens, a dream rendered in his poem *Brise Marine*. An uncontrollable drive to flee from reality, haunts the fancy of the worldweary poets at the turn of the century. Maybe somewhere there still exist those slumbering languorous isles evoked by Baudelaire where nature is lush with strange-shaped trees and luscious rare-flavoured fruits! Provided man has the energy to seek them. When this spirit is lacking, the artist is condemned to wilt and sere in the rarefied climate of decadent, artificial, excentric and neurotic Aestheticism like Des Esseintes, the hero of Huysmans' *À Rebours*. Rimbaud succeeds in mustering the force to flee, preferring adventure to his calling as an artist: "*I am leaving Europe. The sea-air shall scorch my lungs, undiscovered climes shall harden my spirit.*" Painters and writers in the first half of our century, conjured up a theory, seeking in the flight to other horizons as well as in Primitivism, the possibility of pouring fresh life into art.

The luring appeal of exoticism is certainly not a novel trend. Thus, in the 18th and early 19th century, with Delacroix, for instance, we meet exoticism too, even though of a slightly different ilk. Travelling is still just an entertaining pastime satisfying man's curiosity. For Gauguin, however, it became a refuge and salvation proclaiming the total desertion from and denial of European civilization. "*Where is that day ... when I'll surrender my heart to the virgin forests in one of the South Sea islands, there to live and discover peace, ecstasy and art*", he writes in a letter to his wife. Meanwhile, he encounters in Brittany, at Pont-Aven, the simple pathetic beauty in the shrines and crucifixes carved by coarse peasant hands. Here he finds 'The Savage' and 'The Primitive' which he opposes to 'The Hellenic and 'The Great Error', however beautiful the latter might be, and recommends "*to constantly bear in mind the art of the Persians, the Cambodians and even the Egyptians*". Gauguin rejects the Hellenic, witnessing its degeneration into academist Kitsch, and searches for a spirituality that can no longer be found in a Europe drained of its spiritual force. It is in the *barbaric world* that he discovers the fresh rejuvenating springs of Primitivism.

The interest for the primitive begins to gain momentum. There had appeared already in the past some random pieces of Primitive Art, viewed however as bizarre exotic objects rather than as works of art. The next step is a scientific, systematic ethnological investigation; setting up museums of primitive objects. Prompted by intellectual curiosity, roused to a certain degree by the colonialist expansion of the century, Primitivism reflected a Baroque-like propensity in a period of intellectual satiety and spiritual crisis. This interest is reminiscent of the age of the Late Baroque when oddities were gathered in wonder-chambers like the *Wunderkämmern* at the Hradčany palace of the excentric Rudolph II.

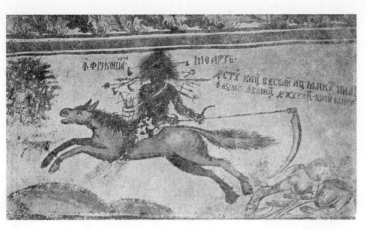
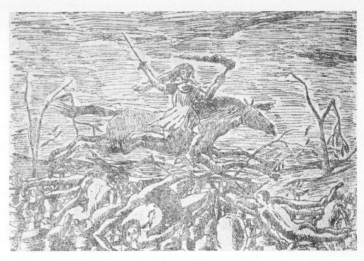

Terrifying Death, HENRI ROUSSEAU
The Church of Fărtăţeşti-Dozeşti, Oltenia *The War*

The primitive is not encountered only in far-flung countries but also in one's own land, either in folk art or in various extra-artistic productions, attractive by its bizarreness. It is in this context that we must set Rémy de Gourmont's quotation. This interest for oddity, undermining the excessively conservative mentality, cleared the path to a break-through into a new artistic climate that first tolerated and then accepted Rousseau's vision of art. Were it not for these circumstances, despite his unflinching tenacity, Le Douanier would never have emerged from anonymity. This new approach which paved the way to his acceptance, was to be his guideline in his artistic calling. The outcome of a fashion himself, Rousseau was to indulge and cultivate this fashion. Not only did it respond to his inner urge but actually became the fulfilment of his life's quest. In return, by sublimating forms he secured a lasting place in the world of art for a fashion which, as fashions go, was otherwise doomed to be a passing whim.

The fabulous stories recounted by his regimental comrades who had returned from the hapless expedition to Mexico, must have cast, into the soul of this provincial young dreamer, the first seeds of exotic spell in images of a gorgeously coloured jungle replete with the fascination of mystery and peril.

The spectacle offered by the exotic pavilions at the Paris World Exhibition in 1889, where entire Annamite and Arabian villages were reconstituted, produced a powerful impression upon Rousseau, rekindling the memories of the stories heard at his regiment, and prompting him to render them in a vaudeville of the time, called: *A Visit to the 1889 Exhibition.* 1891, two years later, is the date of his first canvas depicting a jungle scene: *Trapped.* This was the first step. As time wore on, this theme was to recur ever more frequently like a haunting image. Accepting the banter of his literary friends, Rousseau encouraged his legend as the mythical brave soldier roving through the Mexican jungle.

AN ANARCHIST

On the 1st of December 1863, the clerk of the 51st Infantry Regiment at Angers recorded in the file of the recruit Henri Rousseau: *Height: 1 m 65. Face: oval. Eyes: dark brown. Nose: regular. Mouth: average. Chin: round. Hair and eyebrows: dark chestnut. Distinctive marks: left ear cut off.*

In December 1907, the named Henri Rousseau, who in his extreme naïvety had got involved in a fraud-case for issuing cheques without security, is described in a police-report in the following terms: *"Aged 63, but with the appearance of a man of 50—54. Medium height: approximately 1 m. 65. Normal build. Hair: dark chestnut markedly turning grey; moustache fairly bushy and not too long, likewise strongly turned grey. Face: common; complexion: pale with a few reddish spots; eyes slightly sunken. Walks with his head bent forward, giving the appearance of a sickly-looking man; general demeanour normal; hair at present cut short, formerly worn long."*

The interval of forty years between these two records embraces the life span of the man and the artist. We shall dwell first upon the man, in order to understand the artist better, for it would be inconceivable to separate one from the other, since they represent a dialectic unity linking them together by innumerable visible or invisible threads, where, in the privileged case of this artist, the artistic creation is the sublime prolongation of the personality of the man. At times however, the contrast is so striking that it seems almost incredible to associate the man with the artist. What a tremendous gap, in particular in the case of Le Douanier, between life of the deadliest dullness and the fabulous decor of his paintings! We are naturally inclined to wonder whether the work was not fulfilling a compensatory function, vindicating the grief and grievances of a much tried man and the frustrations of an over-sensitive lyrical artist.

Everything that has been recorded about his life is disastrously grey and frustrating, constantly mourning the loss of those dearest to him. The death of six of his seven children *, followed by that of his first wife, Clémence" ... *my poor wife*, as he wrote himself, *who has left this world so hard for some, after twenty years of pure and sacred communion, in which we only lived for one another, just as our parents had urged us, to ensure each other's happiness. Yes, indeed, these twenty years have been the happiest of my life ...*"
The next loss was that of his second wife, Joséphine. Towards the end of his life, he fell in love with Léonie V., a sour-tempered elderly spinster of fifty four, 'The Sinister Léonie' as his friends called her, whom he vainly hoped to marry. ** Though Rousseau, in spite of his modest resources, showered presents upon Léonie her father refused to consider him a serious suitor. It is at this moment of his life that Le Douanier asked Ambroise Vollard to give him an artist certificate to placate the unrelenting father. To no avail however.

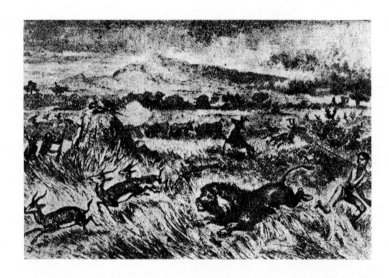

Wild Animals Racing Through the Blazing Prairie, illustration in Baker's *Ismailia*

No social or professional activities can make up for his sentimental torment. After all, what satisfaction could he derive from twenty two years of humdrum clerical works as a petty excise-officer. Paid with a paltry salary that had to cover, besides his daily needs, also the luxury of painting, he is constantly up to his ears in debt.

* Henri Certigny in his admirable reconstitution of Rousseau's biography, remarks upon an error made by Rousseau in the letter addressed to the State Attorney: in point of fact, it was five not six of his children who had died.

** More eloquent than any comment is the text of the letter he wrote to Léonie on August 19, 1910, from which we are reproducing a fragment: *"My dear Léonie. You are always in my mind. Before I go to bed I wish to tell you a word concerning the remarks you made about me at Vincennes when we were sitting on the bench waiting for the tram. You told me that, if I am of no greater use to you, I am at least a source of fun as a buffoon. Whose fault is it that I am of no use to you? Do you really think I don't suffer, do you think I would not be happy to share more often those moments of love, that natural thrill that both man and woman must not forego, since it is a gift granted by nature who destined you for me and me for you. Jesus said: 'No tree or creature is of any use if it does not bear fruit.' Hence it is our duty to bear children, but at our age we need not fear that. You make me suffer bitterly, for, I am happy to say, I am still strong and vigorous. Let's get together and you'll see for yourself whether I am able or not to be of use to you. Cease being so cruel to me, don't rend my heart; when I move close to you to stroke and caress you, you respond to my advances only with excuses and lamentations. Why do you behave so cruelly; since we know each other and love each other ... I assure you, you would be happy in my home, and will not need to seek this happiness elsewhere — for you would be adored and pampered by your Henri who loves you dearly. Why should we cause so much pain to both of us, repeating ungrounded reproaches. Why should we live apart when we can be together ... We could have enjoyed a pleasant happy Sunday tomorrow, happy, tremendously happy. But, no, instead of joy in our hearts we shall be sad and lonely, instead of going together for a walk, to breathe the fresh air in the country, we shall be far from one another. Do you think it's right and fair?"*

The conditions in which he lives are downright squalid. Two photographs from that period picture the shed — without water or lighting — at 3, Rue Vercingetorix, his 'studio' in the so-called *Cour des Miracles*. An old, narrow, and sordid street, with one-storied timber houses. On the pavements — cases; washing hanging at the windows. The entrance to his workshop: wooden stairs that rise, in pitch darkness, to the first floor, straight from the sidewalk paved with cubic stones. Above the doorless doorway, a heap of pipes running parallel, for God knows what purpose. To the left, a niche with some miserable-looking pots of flowers, and to the right, built in the wall, low down, a water-tap.

The interior of his "studio", as described by the poet Léon-Paul Fargue, is no better: "*The room that serves as his workshop is at the far end of a corridor. The window with dust-covered curtains overlooks a coal-heap. A round iron stove with a pipe rising straight into the ceiling; a sort of couch that presumably is his bed, and the vestiges of some battered furniture scattered about, make up the forlorn picture of a man devoid of a wife's care. Under the bed one could seee an iron pot with the stew cooked by the porter's wife on Monday which had to last him up to the end of the week. The place would be sinister were it not for the huge French and Russian banners that hang on the wall waving their joyful colours. On the floor leaning against the walls a few convases. Fargue picks up one: the emaciated full-size countenance of a woman. It is the portrait of Clémence, Rousseau's former wife, 'his great love' who had been dead for about ten years.*" *

All his attempts to escape from this squalor are doomed to failure. In vain does he try his luck competing in various contests: for the decoration of the townhall at Bagnolet or at Vincennes, or for the assembly hall at Asnières; likewise fruitless was his offer to sell his painting *The Sleeping Gypsy* to the Laval Mayoralty, in 1898 . . . "*I am willing to cut the price down from 2000 to 1800 francs, as I wish the town of Laval to possess an artistic token of one of its sons.*"

To illustrate more fully the character and mentality of this artist living in these poverty-stricken conditions, one of the three vaudevilles written by him can serve as an edifying document. Indeed Rousseau was not only a painter but an all-round artist, cultivating alongside his art, music and literature. The play we are referring to is called the *Revenge of a Russian Orphan-girl;* the very title is a salient illustration of the type of melodrama of the Belle Epoque (vide *Chronology*, year 1899). The schematic structure of his characters symbolizing immutable, conflicting, moral traits, the good opposed to the bad (Gide had not appeared yet with his intricate problematic characters), the plot and dénouement where virtue triumphs and evil is defeated, testify to the author's naïve Manichaean vision, alien to all, complicated shades of abysmal psychology. It is this Manichaeanism that underlies his moral unity and spiritual force that remained alive and ardent up to the end of his life.

The trials and hardships of life never tarnished the purity and beauty of his nature, and in particular his emotional sensitivity. "*Fortunately,*" he wrote in one of his suppliant petitions addressed to the State Attorney, "*I loved everything around me, my conduct is beyond reproof . . .*" Of a shy and unassuming nature, yet he never became a callous or insensitive mysanthropist. At the age of sixty he could still suffer the agony of unrequited love. All who had known him never failed to stress his basic kind-heartedness. Though barely able to make ends meet, he still found a penny to aid the poor of his neighbourhood. Hatred was a feeling that never darkened his heart. "*I never hate, never . . .*" he solemnly declared to Roch Grey. The only man who irked him was Matisse: "*If only he were amusing . . . But he isn't, he is depressing, my dear, and distressingly ugly! Look, I'd rather have this, he said, pointing to a perfume advertisement whence a lovely, coy, girl's picture beamed out with smiles.*" **

In his profound need for companionship, he used to organize in his studio musical reunions with a programme of polkas, mazurcas and waltzes, where his humble neighbours would rub shoulders with Apollinaire, Marie Laurencin, Georges Duhamel, René Arcos, Jules Romains, Max Jacob, Picasso and others. With a touch of ceremony, the invitations addressed to his guests were styled in this form: "*Mr. Rousseau requests the honour of your company and co-operation at the intimate artistic reunion which will be held on Saturday . . .*" signed *H. Rousseau*, with the rider: "*pass it on to your friends*".

* The description is drawn from an article written by G e o r g e R e y e r in 'Match' (15 April 1960), and quoted by H e n r i C e r t i g n y.
** *Ap.* H e n r i C e r t i g n y

His great naïvety in art was naturally coupled with a similar candid simplicity in his daily life. Wilhelm Uhde and Apollinaire recall the story related by Le Douanier who complained that at his Excise-office, when on night duty, a ghost would appear, who would cock a snook and poke fun at him; he had been unable to drive him away though he had tried to shoot him down. Another incident, equally grotesque is narrated by Henri Perruchot: "*At his Excise Office, Rousseau was known for his limited intelligence . . . Not being too companionable with his fellow clerks, confiding in none, nor sharing in their gossip, he gained the reputation of a simpleton and, now and again, his colleagues would play all kind of tricks on him which he bore without protesting and at times, without realizing that they were making fun of him. Thus one night, in the wine cellar they perched on top of some barrels a skeleton whose limbs they kept moving by pulling some strings. When Rousseau caught sight of the skeleton he never batted an eye; taking its company for granted, he addressed the skeleton amiably and then went up to ask him whether he wouldn't like a drink.*" We do not know how genuine his reaction was, such as it came down as a legend, or whether it was not he who was making game of the practical jokers; his pretended gullibility being perhaps a proof of his sense of humour. Such stories tend however to over-simplify his portrait. The mild-natured Rousseau appears to have had also a sterner countenance. This reputation is likewise linked with a story. It appears that in his painting *The War*, the corpse on the right, whose eye is being picked by a raven, is the picture of Mr. Tensorer, the lawful husband of Joséphine; the jealous lover thus takes his revenge upon the undesirable spouse. Gustave Coquiot who was well acquainted with Rousseau, presents another extremely realistic image of the artist, an image that we do not mean to edulcorate: "*We are indeed prone to credit him with a kind heart, because of his pictures, filled with angelic candour. But this would be far from the truth. All those who*

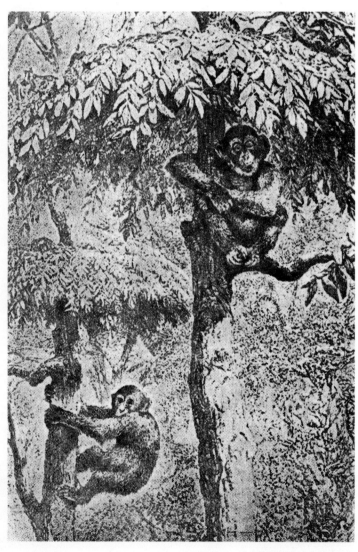

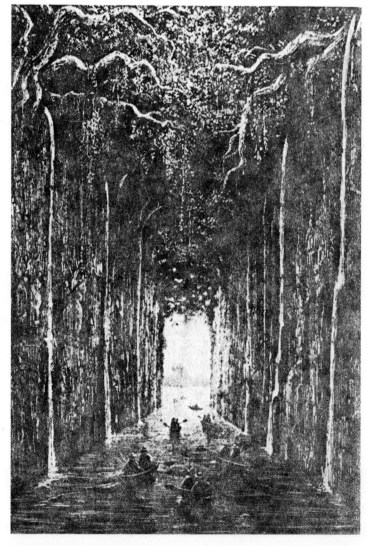

Nshiégo Mbouvés Monkeys in Trees,
illustration in Du Chaillu's
Travels and Adventures in Equatorial Africa

The Straits of Tunkini,
illustration in Marcoy's
Travels Through South America

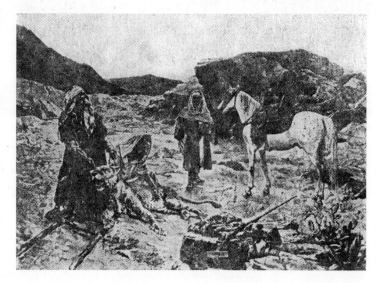

The Tiger Hunt
engraving after K. H. Ernst

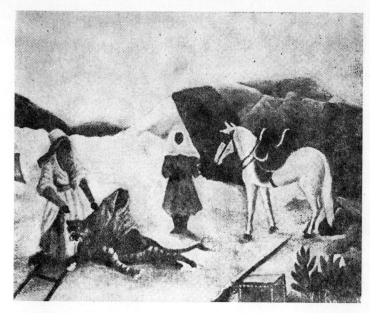

HENRI ROUSSEAU
The Tiger Hunt

have known him more closely remember him as a cantankerous man who could be unbearable and whose spiteful wrath at times exceeded all limits! Though this be true for the man, it is certainly totally insignificant in evaluating the artist."

Trials in life, even when they do not modify the basic character of a man, cannot, however, fail to rouse in him a justified sentiment of revolt which is another form of revenge. This reaction can be detected also in the fairy-like atmosphere of Rousseau's paintings. "*...Since I am bounded,* he writes to Apollinaire, *I must prove to these narrow-minded people, who refuse to see anything but evil. and who are seeking only to run me down, that I am not what they believe me to be. I have suffered deeply...*" (5 March 1910). In another letter of March 11, 1910: "*...I've sent my large canvas to the Salon; everybody finds it good. I trust you will deploy your literary talent and help me take my revenge for all the insults and ignominies I have suffered. I've been told by Picasso that you are the art critic of 'L'Intransigeant'...*"

In what manner Apollinaire vindicated him at the time, we have already quoted.

His revolt is channelled also into politics but in the same sentimental manner. One day he confidentially conveys his secret to Robert Delaunay: *"You know, Robert, I am an anarchist.*"* And yet the anarchist is not devoid of social vanity. He adores titles, and craves after the official glory that his idols — the established Academic painters — enjoyed. He likewise cherished the hope to become rich. That however does not prevent him from professing revolutionary opinions. He is a radical socialist and freemason, of minor rank of course. Contradictions are human and no small number of artists have indulged in them.

The epilogue of this life full of adversities is spent in the solitude of a hospital, a fate he had long been dreading. In vain does he implore 'sinister Léonie' to visit him at his death-bed. In reading the comments of one of those who were present at the last moments of Rousseau's life, Georges Guilhermet, the lawyer who had defended him in his law-suit, we learn that: *"In his ravings, he kept repeating phrases of tragic eloquence. He said he could see God, the seraphim, the archangels, the hosts of heaven. He claimed he could hear angelic music, a divine orchestra of violas, harps, lutes and theorbos. He would set out to paint the stars, the planets and the heavenly dome."*

Seven people, — including Signac — accompanied him on his last journey, to the common grave at Bagneux, following the hearse drawn by two white horses, dyed with a solution of permanganate for the funeral procession. In 1911, Robert Delaunay and Mr. Quéval, faithful friends of the artist, transferred the mortal remains of

* Cf. Henri Certigny: *Robert Delaunay*, in 'Les Lettres françaises', 21—28 August 1932.

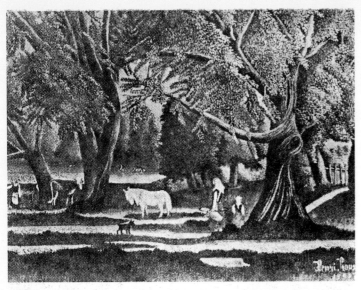 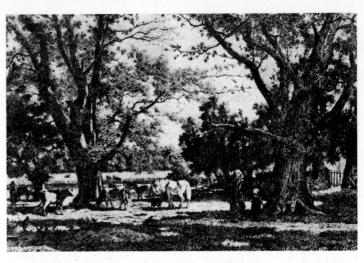

HENRI ROUSSEAU
Summer
(second version)

CAMILLE BERNIER
Spring,
lithograph after E. Pirodon

Rousseau Le Douanier to a private grave leased for 30 years. Brancusi and Ortiz de Zarate carved on the tomb-stone the epitaph written by Apollinaire in pencil:

Gentil Rousseau, tu nous entends
Nous te saluons
Delaunay sa femme monsieur Quéval et moi
Laisse passer nos bagages en franchise à la porte du ciel
Nous t'apportons des pinceaux des couleurs des toiles
Afin que les loisirs sacrés dans la lumière réelle
Tu les consacres à peindre comme tu tiras mon portrait
La face des étoiles *

DON JUANISM AND MAGIC

"We", Rousseau once told Picasso, *"are the two great painters of our epoch, you in the Egyptian style and I in the modern."* No study on Le Douanier ever omits these words. We hardly dare attempt to decode their cryptic sense. Artists always adore to be sententious and often adopt this tone of self-assurance in order to conceal the doubts that constantly torment them. What Rousseau means by *modern* or *Egyptian* styles remains to be interpreted by every subtle commentator. Subtleness however was definitely not one of Rousseau's virtues. The statement, nevertheless, may, in a way, be justified, for no survey of the arts of our epoch dare omit the name of these two representative painters. The opposition between them is total and illustrative. Driven without respite by an unrelenting hybris, Picasso is an artist of the Heraclitic type, symbolic of the unceasing convulsions in which art lives today. *"A painting"*, he declared to Christian Hervos, in an interview in 1935, *"is not preconceived and decided upon beforehand. As it materializes, it imperceptibly changes together with our thoughts. Even when it is completed it continues to vary, according to the frame of mind of the beholder. A painting has a life similar to a human being's, undergoing changes that are imposed upon us by life, day in, day out."* In other words, as he pointed out, a painting is 'a sum of destructions'. Picasso, hence, is not a painter with a coherent vision. Stability, continuity, unity, are all notions to which he never adhered, and this refusal to adhere is a symptomatic feature for all modern art. He is a Don Juan of the arts, and his Donjuanism might be equally interpreted as a desperate quest for the absolute or absolute nihilism. The two notions are, for that matter, not incompatible. This Donjuanism at times leads him astray, allowing his skilled hand too great a freedom to the detriment of the spirit. After all, why rack one's brain to invent something which has been uncovered long before.

* *Gentle Rousseau, you can hear us | We salute you | Delaunay, his wife, monsieur Quéval and I | Let our luggage pass customfree through the gates of heaven | We are bringing you brushes, paint and canvases | For you to dedicate the sacred leisure in real light | To paint — as you did my portrait — | The countenance of the heavenly stars.*

Suffice it to reverse what we said about Picasso, in order to discover, symmetrically, at the opposite pole, Rousseau, a painter of the Eleatic type. Seldom has there been an artist less interested in inventing, more refractory to what André Lhote named 'technical hysterics' of modern art; an artist eminently stable and unitary in his vision.

Rousseau is a painter whose work marks no progressive evolution since his art is defined once and for all from the very outset. There is a spirit that permeates his work, and every canvas is one more element harmoniously incorporated in his vision; this addition destroys nothing of the previous creation, but enhances its value and in its execution reveals the artist's increasing craftsmanship.

If we were to review some of his masterpieces, recalling the date of their composition, we cannot fail to see the same spirit prevalent in his *Carnival Night*, painted in 1886; *I Myself, Landscape-Portrait*, in 1890; *The War*, in 1894; *The Sleeping Gypsy*, in 1897; *The Snake Charmer*, in 1907; *Mr. Juniot's Dog-cart* and *The Soccer Players*, in 1908, and *The Dream*, in 1910. These, together with others unquoted, extend over the whole span of his creative career. This unity and consistency of approach warrant the opinion, voiced in the past and present, by painters and critics alike, that he is an artist who psichologically does not belong to our age.

"*How could this painter of the Middle Ages realize the significance of a cheque?*" was the question raised by his lawyer Georges Guilhermet, before the Jury, at his trial, for having drawn a cheque in excess of his bank account. "*His painting*", he went on "*and even his intelligence goes to a time when cheques were unknown. I would add a fact that confirms the simple-mindedness of this man. When the State Attorney saw the pictures painted by the defendant, he instantly realized that he had taken into custody a Primitive in the fullest sense of the word . . .*" (9 January 1909).

Ardengo Soffici compares him to Uccello, who just like Rouseaus had lived "*in a strange world, at the same time fantastic and real, present and remote, now ludicrous, now tragic; just like him indulging in the luxuriant display of wreaths and garlands, fruit and flowers, in the imaginary companionship of tame animals, wild beasts and birds of paradise; just like him, living a secluded life, working modestly and patiently, greeted with sneers and boos whenever he emerges from his solitude to show the world the fruits of his labour.*" ('La Voce', September 1910, 'Mercure de France', 16 October 1910). In point of fact, Henri Rousseau admired Uccello's art. In this respect, Vasari, ennumerating certain details of the *Universal Deluge* of Chiostro Verde in Florence, mentions a corpse whose eyes are being picked by a raven. It may be just an anecdotic coincidence with the similar detail in Rousseau's *War*. The same picture caused us a further surprise, owing to the startling resemblance with an image of the *Terrifying Death*, in Romanian Primitive Art, appearing as a detail in the votive picture of a Church in Fărtățești-Dozești, Oltenia, of 1939 (*v.* the illustration p. 11)*

André Lhote, likewise regards Rousseau as "*an errant primitive in an age when people have eyes only for mundane adventures and for productions of sham refinement. In the Middle Ages he would have delighted the mob and would have portrayed the saints and donors in rugged, crude yet noble and stately forms.*" ('La Nouvelle Revue Française', 1 November 1923). Adolphe Basler too, repeated the assertion that Rousseau was "*an unwitting Cimabue*" ('L'Art vivant', 15 October 1926), while Kenneth Clark wrote in 1950 that, to his knowledge, before Rousseau no great artist had ever so completely disregarded the style or styles of his epoch, painting instinctively in the manner prevailing four hundred years earlier. Finally, in 1972, Pierre Descargues refers insistently to the work of Toma of Cluj, a Transylvanian craftsman of the 15th century.

Inevitably, some of the details in his canvases are indicative of our days, reproducing technical accessories common to our everyday life. But by a strange process of transfiguration, neither the airplanes, nor the zeppelines, balloons or factory stacks with their pennants of smoke, nor the telegraph posts, water-towers, the Eiffel tower itself, seem to belong to our times. They might rather be found adorning the pages of some old parchment, upon which some fanciful artisan of bygone times limned some flying daemons or other wild dreams. So too did Le Douanier in his fruitful leisure hours envisage these as fairy-like playthings, not as testimonies of a new era in the history of civilization. Detached from a world ravaged by the frenetic upsurge of industrialization, Rousseau subjects and integrates the machine in his artistic vision, refusing to recognize any debt or duty towards it. The stand taken by other artists toward the machine and

* Reproduced by A. P ă n o i u in the volume *Votive Paintings in Northern Oltenia*, Meridiane Publishing House, Bucharest, 1969.

implicitly toward technical civilization is by comparison highly instructive: they contain edifying differences ranging from the Futurists headed by Marinetti paying homage to God-the-Speed and proclaiming that a racing-car is more beautiful than the *Victory of Samothrace*, to the irony of the Dadaists, to end with the daemoniacal machines of Dali or the antimachines of Tinguely. In contrast to these, Le Douanier's Primitivism betokens an artist entirely destitute of any historical awareness — another trait that justifies his inclusion in the category of naïve artists.

The operation to which Rousseau submits these 'historical' details could be described as atemporalization. Townscapes truthful to one epoch are suddenly frozen under the magic of his brush and turned into an eerie Erewhon that only a poet is able to conjure up. Whether it is the *View of the Isle of Saint Louis from the Henry IV Quai*, or the *Chair Factory, Scenes from the Malakoff District* or the *Alley in Saint Cloud Park*, or a humble wedding in a little bourgeois family, the *Viaduct at Auteuil* or the *Footbridge at Passy, The Sleeping Gypsy* in the moon-like desert or the *Snake Charmer* in a 'scented paradise' as Baudelaire would call it, or the jungles teeming with frolicking monkeys and chattering parrots, wild beasts both kind or deadly, all these make up the panorama of a different reality. Here nothing is contradictory, everything is organically incorporated in a whole. We would not be surprised if the perspective of a Parisian townscape faded into an orchard of orange-trees, or if in a glade of a tropical forest suddenly the Eiffel Tower soared up. The fact that a naked woman lolls lazily on a couch in Louis Philippe style in the middle of the jungle, listening to the enchanting flute played by a magician under the wonderstruck eyes of lions and tigers, among fastuous corals, blue, rose and yellow, seems the most natural of things. Henri Rousseau explained to André Dupont why he had placed a sofa in the midst of the jungle: "*The woman sleeping on the sofa*", he said, "*is dreaming that she has been carried into an enchanted forest and hears the sweet sounds of music.*" (1 April, 1910). The woman is dreaming, just as Rousseau himself day-dreamed he was living in a dreamland conjured up by his own fancy. His dreams are made up from: scenes witnessed during his walks in the Jardin des Plantes, picture postcards, chromolithographs, the coloured album for children brought out by Galeries Lafayette with the title name *Album des bêtes sauvages*, periodicals such as 'L'Univers illustré, 'Le Musée des Familles', 'Le Magazin pittoresque' (founded in 1833, which also inspired Cézanne), which published the illustrated adventures of some explorers; etchings with exotic landscapes from Africa, the two Americas, Iceland or Australia, wild animals and numberless other things he deemed worthy of being transfigured and included in his reveries. Adopting them, he enhances their significance by discovering an exterior reality, confirming the poetic reality concealed in his heart, which enables him to live like a king — despite his poverty-stricken conditions — enthralled by the magic joy in the existence of a reality that inspirits his inner reality: two mirrors set face to face responding to each other. This because, as Paracelsus would say, it is not the eye that makes man see, but on the contrary, it is man who makes the eye see by a power residing in his inner self. This force of enhancing the potencial values is explained also by Novalis in his *Magical Fragments* defining Romanticism: "*...to endow the vulgar with a sublime sense, the common with mystery, the known with the dignity of the unknown, the finite with the appearance of infinity...*"

This ability of transfiguration calls for a totally different frame of mind, in odd contrast with the industrial civilization, a spirituality primitive, prelogical and magical. In spite of his progressive political views — that were however only purely sentimental — Rousseau believed in spirits and phantoms. One day, whilst he was working on a landscape, Rousseau asked Wilhelm Uhde (from whom we have this story): "*Did you see how my hand was raised?*" "*That's perfectly natural, since you were painting.*" said Uhde. "*No*", replied Rousseau, "*it was my poor wife who was here and guided my hand. Didn't you see her, didn't you hear her? 'Courage Rousseau' she said to me. 'You will bring it to a good end, I'm certain.'*"

Dora Vallier quotes a painter (P.S.) to whom Rousseau had once said that whilst he was painting a phantasy, he had to open the window as he was suddenly seized with panic.

The minute representation of every detail, every branch, twig or leaf may be associated with that magical weaving of spells practised by primitive peoples known as *Tierzauber*. Before setting out, the hunter would reproduce a drawing of the animal he was to hunt, as a magical incantation that would lure the prey. Is Rousseau's

approach not Magic Realism? Not an intellectual programmatic approach as that applied by the New Objectivity artists, but rather an original, elemental, genuine state. That was most likely Le Douanier's conviction that he could thus penetrate into the heart of the world that fascinated him, a world which, at the other end of the artistic compass, Picasso was fervently struggling to shred to pieces.

A PAINTER UNFETTERED BY THEORIES

The first picture painted by Rousseau, according to the complete catalogue drawn up by Dora Vallier, is *A War Scene in Winter Landscape* of 1877. From Henri Certigny we learn that in 1879, Rousseau reproduced by decalcomania a drawing of a wild beast printed in a newspaper. In 1882 he makes the acquaintance of the Academic painter Clément; in 1885 he sends for the first time two canvases to the Salon. These are his first steps. By his age, Rousseau belongs to the generation of Impressionism; as a painter, from the very outset he stands alone, a solitary artist opposed equally to the innovators that were revolutionizing the arts and to the false Academic tenets locked in the rigorous canons of an antiquated tradition. The spontaneous originality of his vision is a surprising phenomenon: he is a painter without a genealogy. Who does he descend from? Every artist begins by imitation, by pastiche — the picture is born from another picture and the specific individuality of the artist emerges from the clash with 'alien maturities', challenging the forms that others have established. That is what André Malraux affirms. In Rousseau's painting, however, this long-confirmed process is undetectable. An avowed admirer of the Academic painters, it would have been only logical that he should start his carrer by copying these artists. Instead, from the very beginning, he is his own self, partly perhaps because he lacks the technical skill to imitate them. Living in their midst, he got to know their thoughts and experiments which he recorded and stored with the lucid awareness of an artist. Therefore, despite his deficiency in draughtsmanship, he cannot be described as merely an amateur. He bore the consciousness of his artistic destiny in his heart, up to the age of forty, when, according to his own confession, he began to paint. How this consciousness suddenly took shape is unrecorded. What is however evident is the fact that at an age when others reach the prime of their creative powers, he was forced to bear all the adversities of a delayed apprenticeship. Though the paintings of Bouguereau, Clément or Carolus Duran represent the ideal he cherished, he produced, in 1886, *The Carnival Night*, which was already a *genuine Rousseau*.

In an autobiographical note of 1895, written for Girard and Coutance Publishers, who had proposed to bring out a second volume of *Portraits of the Next Century*, Rousseau mentions, among other considerations: "... *owing to the indigence of his parents, he was compelled to pursue first another career than the one to which his artistic taste called him. It was therefore only in 1885 that Rousseau made his début in Art, after surmounting*

HENRI ROUSSEAU
Malakoff, The Telegraph Posts
(study)

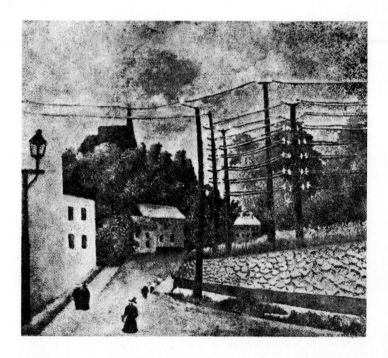

HENRI ROUSSEAU
Malakoff,
The Telegraph Posts

numerous obstacles, alone, with no other master (to guide him) except nature and a few suggestions coming from Gérôme and Clément (...) He has been consistently improving the original style which he has adopted, and is on his way to becoming one of our foremost realistic artists ... " A few years later, in one of the letters addressed to the State Attorney he wrote: "*If my parents had known that I had a gift for painting, as our regretted Clément told them (...) I should now have been the greatest and richest painter in France ...*"

This firm conviction that he was a great artist was reasserted frequently and in extremely categorical terms. He expressed his gratitude to his senior oficials at his Excise-Office, and assured the State Attorney that "*... they have assisted in giving France, our fatherland, one of her citizens who has no other aim in life but to make France more glorious in the world.*"

He worked, like a man possessed, to fulfil his calling, which was crowned with glory, alas! only after his death. "*The years are passing,* Uhde recounts, *and on Rousseau's easel one painting follows another, gaining an ever more mature and profound character; the artist's back is bending in his struggle for life and for his work. Whenever I come to see him. I find him seated on the same chair, the same old man, the image of the inert mob which by its silence, kills artists.*"

The balance-sheet of this five and twenty year activity — in which Rousseau was both an artist with a clear vision and simultaneously an apprentice who had to learn all the arcana of the craft — numbers about two hundred works. There are portraits, land- and townscapes, the famous jungles which he raised to the rank of a characteristic genre, group-paintings and still-lifes. Beyond his vocal bravado we cannot fail to record the genuine faith he had in the originality and artistic value of his works accomplished with tremendous efforts. The painstaking elaboration of a style of his own is manifest. The sketches and the finished painting indicate the transition from the anonimity of the former to the unitary genuineness of the accomplished work. Which was the path he pursued to attain the original style which characterizes his art, he himself would have been unable to explain. He was a painter unfettered by any aesthetic theory. Van Gogh, for instance, was able to justify every stroke of his brush by a detailed analysis, a thing Le Douanier would never have attempted to do. It was not lack of intelligence, but rather the possession of a specific type of artistic intelligence oblivious of, and impervious to any theoretical justification, an intelligence lying in the deeper and more obscure recesses of the mind, closer to instinct. Talking to Arsène Alexandre he stated: "*I always ... see the picture in my mind before I set to painting it, however intricate it is. And yet while I work on it, I discover some surprising things which cause me great delight ...* " ('Comedia', 19 March 1910).

Beyond the experience gained in the solitude of his workshop, where, as 'his own pupil' he forged his own style and personality, it was nature that was his great master and inspirer ... "*this beautiful and great nature which every true artist must worship*" (Letter to the State Attorney, 19 October 1907). In the conversation with Arsène Alexandre quoted above, the added: "*... My greatest joy and happiness in life is to contemplate nature and to paint it. Would you believe it? When I go out into the country and behold the sun, that green foliage, those flowers, I oft say to myself: 'All this belongs to me! Rather bold of me to say so, isn't it?'*". And when Vollard once asked him how he succeeded in suggesting the air stirring between the trees in a picture of his, his simple answer was: "*By observing nature, Mr. Vollard.*"

This veneration of nature is hauntingly present in his favourite themes. The waters and forests acquire in his pictures a strange individuality. They are blue-green still waters, as though springing from nowhere to descend thereupon into deep ravines; waters of an unusual density, heavy waters, populated with mysterious zoological species teeming in their tangled depths, primordial waters such as in the days of Genesis. The obsession for vegetals nurtured by this French petty-bourgeois from Laval, who finds happiness in jungles is a surprising feature in French painting. We encounter it also in that little known bizarre personage Rodolphe Bresdin (*d.* 1885), 'the inextricable engraver', as Robert de Montesquiou called him, a man as sublimely naïve as Rousseau Le Douanier. This obsession haunts above all the fancy of the Germanic painters, evoking the vision of primordial forests, a never-resting laboratory where life and death work out their eternal struggle. Only that Rousseau's paintings despite some scenes of cruelty, bear an air of Edenic bliss and enchantment. The wild beasts whom he feared in everyday life, could be, if not loving, at least docile just as the serpents are

spellbound by the pipe of the snakecharmer and the lions by the flute of the wizard. At times, everything is peaceful — as in the landscape with flamingoes, a canvas worthy of the brushwork of the strange Piero di Cosimo, or in the *Happy Quartet* who had regained paradise.

Rousseau's admiration for reality is conspicuous in the sixteen still-lifes, where all but one contain flowers. Here the vegetal element is tamed in sumptuous chromatic harmonies. The paintings are pervaded with the fervour with which he painted them and suggest a sensitivity that spontaneously calls to mind the poetical Realism of Chardin.

Rousseau's shortcomings are evident in the first place in his drawings, and most acutely in his portraits. It is a useless overestimation to credit his portraits with deliberate effects of a purely intellectual nature. The fact that notwithstanding or rather thanks to his lack of skill, his portraits display virtues of expression, does not entitle us to ascribe intellectual concepts that never crossed his mind. The portraits are just the spontaneous product of his genius. His ideal was to acquire the simple and correct drawing technique of the Academists. His efforts to gain this were downright pathetic. Apollinaire tells us of the minuteness with which Rousseau measured his nose, mouth, ears, forehead, hands and body in order to reduce them in proportion to the dimensions of the portrait he was making. In his group paintings the personages are portrayed as if they were standing before a photographer, with the inexpressive rigidity peculiar to that pioneer period of photography. (Faithful to his declared realistic artistic creed, we may fancy how fascinating the invention of the photographic camera must have been for Rousseau, discovering a lense capable of direct perception of nature beyond the limits of the human eye.)

He has equally great difficulties in rendering the perspective. This deficiency is less noticeable in aerial perspective where his genius as a colourist conceals the flaw by the perfect adjustment of chromatic harmonies, but in exchange is more striking in the linear perspective where the accuracy of the design is essential.

In a highly interesting study, illustrated with juxtaposed images, Dora Vallier demonstrates that, beginning 1891, Le Douanier resorted, first to decalcomania and then to the pantograph in order to overcome this failing. Thanks to the pantograph he was able to achieve his composition, avoiding the difficulties linked with the design. It appears that during a discussion which took place in Othon Friesz's studio in 1910, Rousseau admitted employing a pantograph. Uhde also notes that Rousseau could often be seen copying, at home, prospectuses and illustrated advertisements that happened to be at hand.

Accompanied by Ardengo Soffici, let us now enter the laboratory of the great colourist that Rousseau was. Our guide is trebly competent as a painter, writer and a contemporary who frequented Le Douanier's studio, and recorded his technique: after the picture had been designed in pencil, Rousseau would start applying in succession every colour in a dazzling variety of tones. First he would paint the vegetation, then the sky, the animals, the faces, costumes and objects. Once, as he was completing the foliage in a picture, he exclaimed with a self-satisfied smile: *"Twenty two branches!"* He is supposed to have fixed even the price of his paintings according to the number of tones of every colour. Uhde admitted in his turn too, that he had never heard anyone speaking with greater competence on the employment of colours. The chromatic brillance of his work bears witness to this mastery.

His artistic reputation has — posthumously — substantiated the dedication of the humble excise-officer who wished 'to enhance the glory of France.' *"Henri Rousseau represents the genius of the French people"* writes Robert Delaunay, one of the few real and devoted friends of Le Douanier, *"for his art springs from the deep recesses of the people's soul."*

If we analize more deeply which was the basic source of Rousseau's luminous and powerful genius we cannot fail to discover his profound love for life, in spite of the hardships and adversities he had to endure. Sophie, one of the characters in his vaudeville *The Revenge of a Russian Orphan-Girl* expressed in his own naïve terms better than any other contemporary this deep-rooted faith of our super naïve artist.

"Life is ever full of happines and charm! We cherish the faith that it will remain for ever as pure and as free of sorrow as the glorious azure heaven that today, darkened by no clouds, casts its tender smile upon us!"

CHRONOLOGY
AND CONCORDANCES

1837 In the town of Laval, Mayenne Department, Mr. Julien Rousseau, tinker and tinker's son, aged 29, marries Eléonore Guyard. The bride is the daughter of Captain Jean-Baptiste Guyard of the Foreign Legion, and of his wife Michèle, both deceased; being only 18 years old she is still under the guardianship of her grandfather, Colonel Jean-Pierre Guyard, veteran of the campaigns waged during the Revolution period and the Empire, decorated by Napoleon with the Legion d'Honneur.

1838 Marie-Eléonore, the first child of the young married couple is born on August 18th. Seized by an incurable purchasing mania, Julien Rousseau begins to get into debt which will finally lead to the loss of his entire fortune.

Birth of Count Ferdinand von Zeppelin, the famous constructor of the German dirigible airships.

1839 Eléonore-Louise Renée, the second child of the young Rousseau couple is born on November 22nd.

Birth of Paul Cézanne and Alfred Sisley.

1840 Eléonore-Louise Renée dies on January 14th.

Birth of Claude Monet.

1841 *Birth of Auguste Renoir, Jean-Frédéric Bazille, Armand Guillaumin, Berthe Morisot.*

1844 On May the 21st, Julien Rousseau, accompanied by the citizens Pierre Soutif, hatter and Francis Leroy, tailor, presented himself at the Registrar's Office in Laval in order to register the birth of his son Henri Julien Félix Rousseau, the future Rousseau Le Douanier.

1845 Old Rousseau, the father of Julien, Henri's grandfather dies. Julien Rousseau's 'purchasing mania' is gaining alarming proportions. Resolved to buy the share of the estate belonging to his brothers (Anatole, wall-painter; Renée, milliner and Julie), plunges ever deeper into debt.

Edgar Degas, enters the Lyceum Louis le Grand. Edouard Manet attends a special drawing course at the Rollin College.

1846 Colonel Jean-Pierre Guyard dies.

1848 Jules Rousseau, Henri's brother is born.

Birth of Gauguin.

1849 On September 17th, at the age of five and a half, Henri Rousseau enters the primary school of the Laval College, headed by Abbot Dours. Anselme Jarry, the future father of Alfred Jarry is also a pupil of this college in a higher elementary class.

1851 In the report on the school activities, published by 'L'Echo de Mayenne' Henri Rousseau is mentioned as having been awarded a distinction in Calligraphy and Religion. Julien Rousseau's speculations end catastrophically with the sale of his parental house and the liquidation of his shop.

1852 Julien Rousseau announces in 'L'Echo de Mayenne' his new occupation as wine agent for the local producers. Henri Rousseau is awarded a distinction in Calligraphy.

1853 The award of an honourable mention in Calligraphy and Recitation, at the end of the school-year, marks the scanty achievements of the schoolboy Henri Rousseau.

Birth of Van Gogh.

1854—1860 As Julien Rousseau's wine agency proves unprofitable, he gives up this occupation, moves to Couptrain, where he runs a tobacconist's shop. Henri Rousseau remains at Laval, with his uncle, or rather with his aunt Renée Guyard.
The school report of Henri Rousseau is as pitiful as his father's business transactions, ending in his failure to pass the grade. In 1859 he gets a distinction in Calligraphy and Music, and in 1860 in Music and Drawing. His father's ruin prevents him from continuing his schooling and from achieving his dream of studying Fine Arts.

1855 *Degas and Manet attend the School of Fine Arts. A large number of paintings by Ingres,*
 Delacroix, Théodor Rousseau, are displayed at the World Exhibition. One pavilion is reserved to
 Courbet's works: Realism.
 Renoir works as decorator in a China workshop.

1857 *Baudelaire's* Fleurs du mal *are brought out.*

1859 *Birth of Seurat.*
 Monet moves to Paris.

1861 The Rousseau family is living in Angers; the date of their settling here is unrecorded.
 On December 22nd, the marriage of Henri Rousseau's sister, Henriette Anatolie to Louis
 Rosé, a shop assistant.
 Birth of Louis Vivin, a future celebrity in naïve painting, by profession a post office clerk.

1862 In Mexico, the French Expeditionary Corps that is fighting to save the throne of Emperor
 Maximilian, suffers a resounding defeat at Puebla. Fresh reinforcements have to be sent.
 In August, the 51st Infantry Regiment of Angers contributes two battalions. At that time,
 according to Henri Certigny's minute investigations, Henri Rousseau had not been called
 up, hence he could not have participated in the famous campaign, as he claimed in later
 years.

1863 On March 7th, reporting for enlistment, lots are drawn and young Henri Rousseau
 is luckily among the exempted. Free from his military duties, eager to earn his living,
 he is engaged as clerk to Fillon, the head of a prosperous lawyer's office. His career as
 a barrister's clerk begins none too gloriously. Abusing the trust of his employer, he steals
 five francs worth of stamps and 10 other francs entrusted to him. Scared by the possible
 consequences, finds refuge in the noble career of arms and enlists as a volunteer for a
 period of 7 years. He is registered in the files of the 51st Regiment of Angers, the 1st
 of December 1863.

 Birth of Signac.
 Manet, Pissarro, Jonkind, Guillaumin, Whistler, Cézanne exhibit their works at the Salon des
 Refusés.

1864 Following the plaint of Fillon, a writ of attachment was served upon Rousseau. He is
 tried and sentenced (on February 20th) on one month imprisonment. On the completion
 of the prison term he returns to his regiment to continue his military service, as a
 private; no promotion or rank bear witness to any military achievements or virtues.
 Meanwhile the Angers garrison dispatches another 500 soldiers to Vera-Cruz.
 There is no evidence in *his military record* of his inclusion in this new transport of troops
 to Mexico.

 Birth of Toulouse-Lautrec.
 Birth of Séraphine Louis, named de Senlis, a future celebrity in naïve painting. She earns her living
 as a domestic servant.

1867 The survivors of the expeditionary force sent to Mexico return to Angers on the 7/8
 April. Their adventures in Mexico are a rich subject of colourful remembrances and
 chitchat in the barracks where Private Henri Rousseau is serving his uneventful military term.

1868 Julien Rousseau dies (on February 6th). Thus becoming the only "support of the family",
 Henri Rousseau leaves the army (15th July) by the effect of the law granting unlimited
 leave to sons of widows. Settles in Paris renting a room at Mrs. Boitard's, the widow
 of a small furniture dealer. Falls in love with Clémence Boitard, the landlady's daughter
 to whom he gets engaged. He earns his living as assistant to the bailiff Radez.

1869 On August 14th the civil marriage and wedding ceremony of Henri Rousseau with Clémence
 Boitard. The newly-wed couple live at 25 Rue Rousselet, the same building where
 Barbey d'Aurevilly had stayed for a time.

 Birth of Henri Matisse.

1870 Henri Anatole Clément Rousseau, the first child of the young couple is born on May 20th.

 The Franco-Prussian War breaks out.

 Henri Rousseau is drafted but takes part in no campaign. As head of a family supporting
 a widow, he is exempted from active service and kept in the garrison. The absence of any
 mention in his military papers of any military achievement refutes the legend cultivated
 by Apollinaire regarding the glorious acts of gallantry of 'Sergeant Rousseau'. He was
 reported to have rescued the town of Dreux from the 'horrors of war' and to have been
 enthusiastically acclaimed by the liberated citizens of this town who cried in gratitude
 'Long live Sergeant Rousseau!' This would not be the only occasion when the poet of
 Alcools proves to be a naïve victim of the stories of bravery made up by this war veteran,
 stories prompted partly by megalomania, partly by his waggish sense of humour.
 Apollinaire believed with the same good faith also in Rousseau's famous Mexican campaign,
 which he even evoked in verses: *"Do you remember, Rousseau, the landscape of the Aztecs,*

| the orchards where luscious mangoes and pineapples grow | the monkeys spilling the blood of the melons | and where the fair-haired Emperor met his death. | The pictures you paint you've seen yourself in Mexico. | A scarlet sun adorning the crown of the banana trees | And you, valiant warrior, have changed your tunic | Into the blue coat of the worthy Customs officer.

In point of fact, Henri Rousseau never reached the rank of sergeant, satisfied with the anonymous position of a private.

1871 Henri Anatole Clément Rousseau dies on January 17th. Henri Rousseau is engaged as junior Excise Officer (December 8).

Birth of Rouault.

1872 Henri Rousseau's daughter, Antonine-Louise is born (on July 5th).
Birth of Dominique Peyronnet, a future celebrity in naïve painting; by profession type-setter in a printing house.

1873 *Degas paints his series of dancers; Monet, at Argenteuil, paints regattas; Cézanne works in Antwerp adopting Pissarro's technique; Renoir settles in Montmartre and Manet at Berck-sur-Mer.*
Birth of Alfred Jarry.
Birth of André Bauchant, a future celebrity in naïve painting, by profession a farm-hand.

1874 Julie-Clémence Rousseau is born on January 27th and dies the following day.
Henri Rousseau is appointed Excise Officer 2nd class.

Birth of Wilhelm Uhde, writer, art critic and art collector, at Friedeberg, in Brandenburg. This 'last great lord of painting' and first biographer of Henri Rousseau (in 1911) showed great friendship and understanding. Uhde was likewise the critic who discovered Séraphine de Senlis.

1876 Another daughter is born, christened likewise Julie-Clémence on June 11th. She died in 1956, leaving a daughter Jeanne Bernard.

1879 Henri Anatole Rousseau is born on April 27th.

1881 *Birth of Picasso and Fernand Léger.*

1882 Another child is born to Henri Rousseau. According to his statement made in the letter addressed to the State Attorney, in 1907, he appears to have had 7 children. Henri Certigny, his most trustworthy biographer, after exhausive investigations, could only record 6 children. Like all amateur artists, Henri Rousseau paints at home, but hopes to be able to have a studio as soon as his salary is raised.
The Bottin Year-Book, records the new address of Mr. Félix Auguste Clément, painter and academician, at 137 Rue Sèvres. Thus the well-known Academic painter highly reputed at the time becomes the neighbour of Henri Rousseau and is the first established painter to advise and guide his humble amateur fellow artist. Among the people frequenting Clément's house are his fellow-academicians Gérôme Cabanel, Bouguereau, Bonnat, Ralli, the sculptor Valton and others. In a letter sent to the critic André Dupont, Henri Rousseau declares:"*. . . if I have preserved my naïvety, it is due to Mr. Gérôme, Professor at the School of Fine Arts, and Mr. Clément, Director of the School of Fine Arts in Lyon, who steadily advised me not to give it up.*"
Twenty five years later, Henri Rousseau explained to the State Attorney: "*I was encouraged by painters who were already famous such as Gérôme Cabanel, Ralli, Valton, Bouguereau, . . .*"
In another letter he quotes Clément and Bonnat (v. Henri Certigny).

1883 *Boudin, Monet, Renoir, Pissarro, Sisley exhibit their paintings at a private show at the picture gallery of the art-dealer Durant Ruel. Birth of Camille Bombois, a future celebrity in naïve painting, who earned his living practising such various occupations, as farm-hand, circus wrestler, pointsman, day labourer, etc.*

1884 Thanks to a recommendation from Clément, Henri Rousseau obtains an authorization for the Louvre, Luxembourg, Versailles and Sait-Germain museums.

1885 Sends two canvases to the Salon in Champs-Elysées: *An Italian Dance*, remarked by Signac, and *Sunset*. In a note written to his lawyer a few years later he adds the information: "*One of them was slashed with a pen-knife; for which I received no compensation. On account of that I exhibited my painting again with the 'Refusés' group exhibition held in June.*"
With reference to these two canvases, L. de Beaumont writes in 'La Vie moderne':"*. . . I spent an hour in front of these masterpieces, studying the faces of the visitors. There was not a single man who failed to split with laughter. Oh, Happy and God-Blessed Rousseau!*"
He hires studio at 18a Marine Alley. Full of understanding, his superiors at the Excise Office, spare him of too much work, allowing him free time for painting. Le Douanier's clerical career is none too brilliant.

1886 Invited by Signac, Henri Rousseau exhibits at the Salon des Indépendants: *Carnival Night, Landscape at Sundown, Awaiting* and *A Thunderbolt.* He is remarked and highly praised by Pissarro. Among the artists grouped as Indépendants are: Guillaumin, Redon, Seurat, Cross, Schuffenecker, Valton, Dubois, Pillet and others.

The French Musical Academy awards Rousseau a diploma for his composition *"Clémence, a watlz with an introduction, for violin or mandoline"*, presented, according to his statement, at the Beethoven Hall, before a large audience.

The eighth and last exhibition of the I m p r e s s i o n i s t s.
Van Gogh arrives in Paris. Gauguin at Pont-Aven.

1887 Exhibits at the Indépendants (between March 26-May 3): *View of Quai d'Orsay in Autumn, A Poor Wretch, View of an Alley in the Tuilleries, in Spring.*
His works are remarked by Odilon Redon, by Maximilien Luce and Gustave Coquiot. As H. Perruchot pointed out, Redon and Coquiot expressed their commendation for *the genius of this Naturalist painter who at times rises to the heights of a fine clasic style.* The critic Desclozeaux, in 'L'Estafette' likewise commented *"the very original canvases of Mr. Henri Rousseau"*. The public on the other hand does definitely not share his view, for *"... cries and outbursts of laughter shook the walls"* (G. Coquiot).
In spite of it, Henri Rousseau confident in his talent, applies for a subsidy to continue hie studies in painting.

Birth of Juan Gris and Chagall.
Lautrec and Van Gogh adhere to Pointillism.
Death at Eferding (Austria) of Alois Zötl (b. 1803).
Since 1832, for a period of 12 years, this tanner spends his spare time conjuring up some extremely strange zoological plates. Without having ever left his native soil A. Zötl, haunted by exotic reveries, paints about 320 watercolours, representing a rich collection of wild animals in a spirit and edenic setting akin to Rousseau's.

1888 Exhibits five painting at the Indépendants, including a *View of the St. Louis Island* as well as five drawings. Death of Clément. On the margin of the obituary, Henri Rousseau adds the words:*"... for whom I must preserve a deep feeling of esteem and gratitude, though he is gone; for he always gave me sound advice."*
Clémence Rousseau dies of consumption, at the age of 37 (8th May).
Paints the canvas *The Artist's Wife in a Garden.*

Van Gogh at Arles.
The Nabis gather at the Julien Academy.

1889 The World Exhibition is opened in Paris (May 6). Henri Rousseau is an assidous visitor of the Exhibition and *"most certainly it is here that the Tarantula of exoticism bit him. He was likewise highly impressed by the Eiffel Tower* (built for the Exhibition) *for he repeatedly painted it. He preserved a vivid memory of the Arab and Anamite villages; indeed, exchanging the brush for the pen, he composed the vaudeville named* 'A Visit to the 1889 Exhibition'" (H. C e r t i g n y).
Exhibits at the I n d é p e n d a n t s: *To My Father, The Portait of Mlle Lepallier, The Portrait of Mrs. G, Suicide.* "I have never met something more grotesque", writes L. Roger-Milès *"than Suicide, the portraits painted by Mr. Rousseau, and the Starlit Night by Mr. Van Gogh, with the sole difference that with Mr. Van Gogh it is a matter of insanity, while with Mr. Rousseau it is sheer ignorance of the technique of drawing and painting. If in future exhibitions the jury will deprive us of such valueless freakish specimens then I propose that this jury should never be dissolved."*
He paints: *I Myself. Landscape Portrait.* "I am", Rousseau writes to the State Attorney, *"the creator of the landscape portrait, as quoted by the Press; I have been frequently commended by our regretted Carnot, as well as by General Brugère, a fact reported in the newspapers."*
Begins a love-affair with Joséphine le Tensorer, wife of Olivier le Tensorer, a native of Brittany, who died a few years after. The latter's profession is unknown, except for the fact that before he died he was a coachman.

1890 Exhibits at the I n d é p e n d a n t s several drawings as well as five canvases, including *I Myself, Landscape Portait.*
Eléonore Rousseau, the artist's mother, dies.

Death of Van Gogh.

1891 Exhibits at the I n d é p e n d a n t s: *View of Malakoff, View of Bois de Boulogne, The Passy Gangway,* two portraits, *Family Group, Hunter on Foot* and *Trapped.* Before Rousseau was discovered by Jarry, Rémy de Gourmont and Apollinaire, a young gifted Swiss painter and writer, Félix Valloton writes about Le Douanier: *"Mr. Rousseau is every year more astounding, but he never fails to catch the public's eye: backs sway with hilarious outbursts and the halls echo with beholders' laughter. He is a dangerous neighbour, for he crushes every-thing around. His tiger who surprises his prey deserves to be seen: it is the Alpha and Omega of painting, and so baffling that the most deep-rooted convictions are suspended (and waver) at the sight of such self-sufficiency and childish naïvety. Not everyone breaks into laughter, though, and some who would be tempted, refrain from doing so for it is always moving to meet a faith, whatever it may be, expressed with such inflexible perseverance. I for one nurture a sincere appreciation*

for these strivings and I prefer them hundreds of times to the pitiful horrors hanging nearby..."
'L'Argus de la Presse', to which Rousseau had subscribed in order to receive the newspaper cuttings in which his name was mentioned, sent him an extract with the following content: *Paris city contest. Silver medal awarded to Henri Rousseau for his paintings.* The prizewinner was not our artist but a namesake of his; which did not however prevent Henri Rousseau from adding to his visiting-card the title 'prize-winner'.

Van Gogh show at the Indépendants.
Death of Seurat.
Bonnard makes his début at the Indépandants.

1892 Exhibits at the Indépendants: *Centenary of Independence* with the commentary: *The people dancing around the two Republics, the one of 1792 and that of 1892, to the tune of Auprès de ma blonde, qu'il fait bon, fait bon.*

1893 Exhibits at the Indépendants: *The Last Man of the 51st Regiment, Liberty, View of Vanves after Rain, St. Louis Isle on the Night of the Bus Depot Fire on the Estrapade Quai, Portrait of Mr. B.*
Takes part in the contest for the decoration of the Bagnolet Town Hall. Without avail. The prize would have been 4,000 francs. Retires from the Excise Office with the rank of Excise Officer 1st class, and with a yearly pension of 1019 francs. Up to that date, he had painted only the pictures exhibited at the Indépendants as well as about 200 drawings. At last, he is able to dedicate himself henceforth exclusively to painting. Moves to 44 Rue Maine.

Ambroise Vollard opens his gallery.
Gauguin exhibits his Tahitian paintings at the Durand Ruel Gallery.

1894 Exhibits at the Indépendants: *Portrait of a Child, Portrait of Mr. J., Decorative Panel* and *The War*, commented with the following reflection: "*She* (the war, symbolized as a woman) *sweeps past spreading Terror, Despair, Tears and Ruin.*"
It is at this salon that Henri Rousseau is said to have met Alfred Jarry. Here is a note of Fernand Lot describing this encounter: "*Charles-Henri Hirsch, from whom I obtained this detail was accompanying Jarry at the* Indépendants, *when they both stopped dead in front of an extremely hilarious canvas. It was called* Earthly Paradise. *In the forefront painted with the painstaking clumsiness of a child was a tiger lying stretched out, with a streamer in his muzzle. A little man with white hair stood like a sentry beside the picture.*
— *Do you like it? he asked.*
— *It is simply sublime, exclaimed Jarry in a convinced tone. But who are you, Sir?*
— *Henri Rousseau, the author... replied the little man.* (v. H. Certigny).
Anatol Jakovsky, a specialist in naïve art, claims that the *Paradise* is not the work of Henri Rousseau but of Jean Guiraud, likewise a naïve painter.

Jarry sits for a portrait by Henri Rousseau. Gauguin, returned from Tahiti, visits the Salon des Indépendants *where he is supposed to have commented Henri Rousseau's inimitable black pigments.*

1895 Exhibits at the Indépendants six landscapes, including *View of the Montsouris Park* and four portraits.
Accompanied by Jarry, Rémy de Gourmont visits Henri Rousseau and commissions a lithograph for his review 'L'Ymagier'.
As a member of the 'Friendship' orchestra of the District, meets another amateur musician, named Louis Sauvaget, aged 17, who was to cause him later serious legal troubles.

Cézanne exhibits at Vollard's gallery.

1896 Exhibits at the Indépendants several works including 'A Philosopher'. Judging by the commentary-poem, not published in the catalogue, where Henri Rousseau explains the lost painting, in his personal manner, the theme appears to be that of a sandwich-man. "*Following the example of the great philosopher Diogenes | Though not living in a barrel | I am, like the Wandering Jew in this world | Fearing neither tempest nor flood | Walking with calm steps while puffing at my old pipe | Bravely defying lightning and thunder | To earn an honest penny | Though the rain pours down upon the earth | I bear on my back, with never a cry | The poster of the independent journal 'L'Eclair'.*"
Moves to 14 Rue Maine to buy paints from Foinet, a friendly and generous dealer to whom he gets indebted beyond his means.

Alfred Jarry writes his famous farce Ubu-King, *a fierce parody of the fashionable plays of the time, as well as an acid satire of the megalomaniac bourgeoisie which is mean, cruel, cowardly and unscrupulous.*

1897 Rousseau's son Henri-Anatole, engraver, dies (25th of February). Exhibits at the Indépendants the portraits of Mr. and Mrs. E.F., the portrait of Miss M. and the *Sleeping Gypsy*.
A journalist, Faverolles by name, writes in 'Le Gaulois': "*Ladies and Gentlemen, if you wish to amuse yourselves, pay a brief visit to the* Indépendants. *You will have the delight*

of contemplating among other pictures, the bewildering work of Mr. Henri Rousseau: The Sleeping Gypsy *! The scene represents a negro woman sleeping on the bare ground; a lion sniffing at her, in order to explain to the viewers the unaccountable peacefulness of the scene; there is an inscription on the frame: 'The feline, though ferocious, hesitates to pounce upon his prey, who, exhausted, has fallen into a deep sleep' ".*

Years after, in the preface, of a catalogue, Jean Cocteau commented thus on this masterpiece of Henri Rousseau's: *"We are in a desert. Her dream carries the sleeping gypsy girl far into the background, or maybe her dream brings her forward to us from far far away, just as the vision shifts the river to the fourth plane, so that a lion in the third plane sniffs at the girl, yet is unable to reach her. Maybe this lion and this river are only in the sleeping girl's dream. Such peace! Mystery, fancying itself to be alone, sheds its veil ... the gypsy is sleeping, her eyes are closed ... Could I ever portray this figure motionless yet flowing, this river of oblivion? My thoughts wander to the Egyptians who were able to keep their eyes wide open in death, like divers in the sea ... Whence has she dropped? From the Moon ... Maybe the painter who forgets no detail, has unwittingly traced no footsteps around the feet of the sleeping woman. The gypsy did not come there. She is actually not there. She is lying on no human soil. She rests deep inside mirrors, that reflect a still life, foreshadowing the Cubist vision."*

Jarry addicted to drink, and leading an 'Ubu'like life himself, lives at Henri Rousseau's for a while. Gauguin paints Where do we come from? Who are we? Wither are we going?
Exhibition of Impressionist painting in London and Stockholm.

1898 Competes unsuccessfully in the contest for the decoration of the Town Hall of Vincennes; the sum offered for this purpose is 30,000 francs.
Exhibits at the I n d é p e n d a n t s five works including *Struggle for Life* and *View on Rue Louis-Blanc at Alfortville.*
Offers his picture *The Sleeping* to the Mayoralty of Laval, who refuse to purchase it.

Death of Gustave Moreau and Puvis de Chavannes.

1899 Moves to his new address at 3 Rue Vercingetorix.
Completes his melodrama, in 5 acts and 14 scenes, *The Revenge of a Russian Orphan Girl.* The action begins in St. Petersburg, continues in Brussels and ends in St. Petersburg again. The heroine, the young and pure Sophie, is seduced by the unscrupulous young Henri, who deserts her. Simulating a suicide he marries a rich heiress. Bosquet, a noble-hearted retired general adopts the luckless Sophie. After some time the latter discovers Henri's foul trick, and at a masked ball, where she meets him she reveals her true identity concealed under her mask. The shame and remorse of the infamous Henri are of little avail, for Gaston, a gallant lieutenant in the Tsarist Navy, who cherishes the purest love and devotion for Sophie, challenges the vile seducer to a duel, and, sure enough, kills him, thus assuring the unmitigated triumph of virtue and public morality.
The plot and the very spirit of this melodrama abundantly express the mentality and vision of Henri Rousseau. Some dialogues as well as some indications of the settings, suggest ideas easily convertible into pictures by ... Henri Rousseau: *"Oh Lord!"* exclaimed Yadwigha, one of the characters", *how scorchingly hot it is. I feel as though I were in Senegal or in one of those exotic countries where boundless forests with coloured trees are peopled with cannibals and more, or less fierce wild beasts."* Or as a sort of sketched portrait: *"Sophie enters, clad in a white dress, with a blue sash round her waist, her ash-blond hair hanging over her shoulders she wears the little apron customary in Russia."* Or the following stage-instructions: *"One can see the square in front of the Town Hall of Brussels, where itinerant wendors and mountebanks have come for the kermis, the yearly fair with its merrymaking and Flemish dances",* etc., etc.
Marries Joséphine Noury, Tensorer's widow (2nd of September). So, at last, the troublesome husband will cease to cast a shadow upon their happiness. In spite of his convictions as a freemason, Henri Rousseau accepts to celebrate the marriage in the Church of Notre-Dame-des-Champs.
Sends no work to the I n d é p e n d a n t s.

The Nabis exhibit at Durant-Ruel's gallery.

1900 Competes unsuccessfully again, for the decoration of the Festivity hall in Asnières.
His daughter Julie-Clémence gets married. Sends no work to the I n d é p e n d a n t s.
Gives up his studio in Rue Vercingetorix and moves into the house at 36 Rue Gassendi.

1901 Exhibits at the I n d é p e n d a n t s seven canvases, including *La Cour des Miracles, The Portrait of Mr. H. ...,* *Spring* and the *Unpleasant Surprise.* In connection with this last painting, Renoir is said to have declared to Vollard: *"I'm sure that Ingres himself would not have disliked this sort of thing!"* His debt to Foinet, his paint dealer, reaches the considerable sum of 614.80 francs.

Apollinaire arrives in Paris.

1902 Exhibits at the I n d é p e n d a n t s ten works, listed in the catalogue with their estimated price: *Happy Quartet* (2000 francs), *Portrait of a Child, Portrait of Miss L ...,* *The*

Bridge in Asnières at Sunset (200 fr.). *The Asnières Quai* (350 fr.). *Landscape at Alfortville* (150 fr.). *A Corner in Bellevue (at Dusk)* (90 fr.). *The Bunch of Flowers* (60 fr.). *Drawings* (100 fr.).

The Italian Futurist Ardengo Soffici who participates in this Salon buys some of Henri Rousseau's works and writes about him.

Gives a course for grown-ups sponsored by the Philotechnic Association. Every Sunday, teaches drawing, water-colours and painting at the Town School. The lessons are not paid, but are compensated by the local clientele he acquires.

Retrospective Exhibition of Toulouse Lautrec's painting at the I n d é p e n d a n t s *and at Durand-Ruel.*

1903 Joséphine dies on March 14th, at the age of 51. Fulfilling the promise he had made to his wife, Henri Rousseau arranges a religious funeral service, forgoing his masonic convictions for the second time. Exhibits at the I n d é p e n d a n t s pictures of flowers and landscapes. The press comments are few and generally unfavourable.

In his new home in Rue Gassendi, Henri Rousseau gives music lessons.

The S a l o n d ' A u t o m n e *is inaugurated.*
Death of Gauguin.
The Wright Brothers make their first flight on a plane of their own making, a sort of glider, with an internal explosion engine, launched by a catapult.

Appointed full professor at the Philotechnic Courses. Exhibits at the I n d é p e n d a n t s: *Scouts Attacked by Tiger, Portrait of a Little Girl,* two portraits of children, *Flowers.*
Furetières, a journalist, 'a brilliant imbecile' as H. Certigny calls him, assures his celebrity in this year by the detracting articles published in 'Le Soleil' and 'L'Evénement'.
Unable to pay his debt to Foinet, his paint dealer, Henri Rousseau leaves him his paintings which Foinet cuts out to recuperate the canvas.

Brancusi arrives in Paris.
Kirchner discovers at the Ethnographic Museum in Dresden the works of the Indians of the Micronesian Isles.
Monet exhibits the set 'Views of London.'

1905 Exhibits at the I n d é p e n d a n t s: *The Wedding, Portrait of Mr. G., Portrait of Mr. C. . . . Avenue of Brittany.*
The death of Bouguereau, the Academist painter (on August 19th) produces a 'profound impression' upon Henri Rousseau, recounts W. Uhde.
Exhibits at the *Salon d'Automne: The Lion being hungry pounces upon the antelope and devours it: the panther anxiously waits for its share. Birds of prey have already wrenched a bulk of flesh, while the poor animal sheds a tear! Sunset* as well as two landscapes on the banks of the river Oise.
He moves to No. 2a Rue Perrel.

Retrospective Exhibitions: Manet at the S a l o n d ' A u t o m n e, *Seurat and Van Gogh at the* I n d é p e n d a n t s.
A Fauve hall at the Salon d ' A u t o m n e.

1906 Exhibits at the I n d é p e n d a n t s the canvas: *Liberty Inviting Artists to Participate in the 22nd Exhibition of the 'Indépendants',* as well as the so-called *Portrait of Pierre Loti,* which in point of fact is that of Edmond Franck, a man of letters.
Georges Courteline buys this portrait for his personal 'Horror' museum.
Exhibits also at the *Salon d'Automne.*
Meets Apollinaire and Robert Delaunay.

Gauguin Retrospective Show at the S a l o n d ' A u t o m n e.
Death of Cézanne.

1907 Exhibits at the I n d é p e n d a n t s: *Representatives of Foreign Powers Come to Greet the Republic as a Token of Good Will and Peace, The Little Cherry-Pickers, Meditation, View of Alfortville.*
Meets Wilhelm Uhde.
Commissioned by Robert Delaunay's mother, paints one of his masterpieces: *The Snake Charmer.*
Louis Sauvaget, a colleague from the 'Friendship' orchestra works out a fraudulent scheme, in which Rousseau is involved. Taking advantage of the latter's credulous nature, Sauvaget pretends that some dishonest bankers have stolen all his savings and that he can only recover them by a banking operation. He must therefore open a bank account, under a borrowed name, with the Banque de France, from which he would obtain a cheque-book. Rousseau agrees to this scheme and obtains cheques with no security. He is caught and on September 2nd, at the age of 63, he is taken into custody at the Santé Prison. As his guilt is juridically evident, the matter may have very serious consequences. In despair, he applies to V. Pannelier, the general counsellor, who, being likewise a freemason, intercedes in favour of the unhappy painter and obtains his temporary release (31st December).

As a savoury detail, his letter of the 6th of December addressed to the State Attorney contains the following candid proposal:

"...*If in your kindness you will grant me my freedom, I shall paint a fine portrait of you in the form and size you may wish, or I will present you as a gift one or two pretty landscapes of your choice.*"

Retrospective Exhibition of Cézanne's works at the S a l o n d' A u t o m n e.

1908 Exhibits at the I n d é p e n d a n t s: *Jungle: Tiger Attacking a Buffalo, The Soccer Players, Portrait of a Child* and *Landscape*.
Henri Rousseau has become increasingly well known making up for his tribulations during all these years. Wilhelm Uhde buys his pictures — and he is not the only one — and organizes a private show of his paintings in a shop in Montparnasse. Apollinaire keeps up his legend and sits for a portrait together with Marie Laurencin *(Muse Inspiring the Poet)*; Picasso gets up the famous banquet at Bateau-Lavoir, in Rousseau's honour.
In his turn, Henri Rousseau arranges musical parties where the *Marseillaise, Paloma,* compositions by Gounod are performed together with the '*Clémence' Waltz,* polkas and mazurkas.

Monet in Venice.
There is a growing interest in the various forms of Primitive Art: The Abbé Breuil publishes his notes on the wall paintings at Altamira.

1909 Exhibits at the I n d é p e n d a n t s: *Muse Inspiring the Poet*. At his trial where he is charged with fraudulent operations together with Sauvaget, the council for the defence Georges Guilhermet, exclaims: "*Gentlemen, return Rousseau to his art, return to Art this exceptional being; you have no right to sentence a Primitive.*" The verdict: two years of imprisonment with suspended judgment. Falls in love with Léonie V., the 'Sinister Léonie.'

Monet exhibits his set of N y m p h é a s *at Durand-Ruel.*

1910 Exhibits at the I n d é p e n d a n t s: *The Dream*, bought by Vollard, who purchases a large number of his works. Among the purchasers are also: W. Uhde, Ardengo Soffici, Brummer and a future important art dealer in New York, Baron Oettinger, a.o.
On September 2nd, at the Necker Hospital, Henri Rousseau dies in the presence of his humble friend Mr. Quéval, a foundry-worker by profession, and his wife. The cause of his death, a gangrene of his leg.

1911 The first Retrospective Exhibition of Rousseau's works at the I n d é p e n d a n t s (45 paintings and 5 drawings).
W. Uhde brings out the first monograph dedicated to H. Rousseau Le Douanier.

1912 Rousseau Exhibition at the Bernheim-Jeune Gallery (27 paintings and 2 drawings).

1913 A Rousseau Hall at the *Autumn Salon* in Berlin.

1920 Robert Delaunay publishes his recollections on H. Rousseau (in 'L'Amour de l'Art', November 1920).

1921 Public sale of W. Uhde's collection. Henri Rousseau's paintings attain high prices.

BIBLIOGRAPHICAL SUMMARY

HENRI ROUSSEAU LE DOUANIER — *La vengeance d'une orphéline russe,* Pierre Cailler éditeur, Genève, 1947.
HENRI ROUSSEAU LE DOUANIER — *Une visite a l'Exposition de 1889,* Pierre Cailler éditeur, Genève, 1947.
HENRI CERTIGNY — *La vérité sur le Douanier Rousseau,* Plon, Paris, 1961.
DORA VALLIER — *Tout l'œuvre peint de Henri Rousseau,* Flammarion, Paris, 1970.
JEAN BOURET — *Henri Rousseau,* Ides et Calendes, Neuchâtel, 1961
PIERRE DESCARGUES — *Le Douanier Rousseau,* Skira, Genève, 1972.
PIERRE COURTHION — *Henri Rousseau,* Hazan, Paris, 1956.
ARDENGO SOFFICI — *Trenta artisti Moderni Italiani e Stranieri,* Vallecchi Editore, Firenze, 1950.
GUSTAVE COQUIOT — *Les Indépendants,* Ollendorf éditeur, Paris, 1921.
AMBROISE VOLLARD — *Souvenirs d'un marchand de tableaux,* Editions Albin Michel, Paris, 1937.
ANTONINA VALLENTIN — *Picasso,* Editions Albin Michel, Paris, 1957.
WILHELM UHDE — *Henri Rousseau,* Figuière, Paris, 1911.
HENRI PERRUCHOT — *Le Douanier Rousseau,* Ed. Universitaires, Paris, 1957.
OTTO BIHALJI-MERIN — *Les peintres naifs,* Delpire éditeur, Paris.
ANDRÉ MALRAUX — *Les vois du silence,* Gallimard, Paris, 1951.

LIST OF ILLUSTRATIONS

Oil, 200 × 115 cm.
Ex-Gourgaud Collection, Paris
8. I MYSELF. LANDSCAPE-PORTRAIT
1890
Oil, 146 × 113 cm.
Národny Gallery, Prague
9. CHILD WITH ROCKS
1895—1897
Oil, 55 × 45 cm.
National Gallery, Washington, D.C.
10. THE RIVER BANK
1896—1898
Oil, 21 × 39 cm.
Private Collection, Charpentier Gallery
Paris
11. THE MILL AT ALTFORT
Toward 1902
Oil, 37 × 45 cm.
W. E. Josten Collection, New York
12. ROUSSEAU AT HIS LAMP
Toward 1899
Oil, 24 × 19 cm.
Ex-Pablo Picasso Collection, France
13. OUTSKIRTS, VIEW OF THE CHAIRS-
SHOP AND THE BANKS OF THE
SEINE AT ALFORTVILLE
1897
Oil, 73 × 92 cm.
Walter Collection, Paris
14. THE PRESENT AND THE PAST,
MEDITATION
*(Separated from one another / And from
those they had loved / Together again /
Faithful in their Thoughts)*
1895—1899
Oil, 84 × 47 cm.
The Barnes Foundation, Merion
15. IN THE VINCENNES WOODS
1901
Oil, 45 × 55 cm.
Private Collection, Basle
16. ARTILLERYMEN
1895
Oil, 81 × 100 cm.
Solomon R. Guggenheim Museum, New
York
17. CHILD AND JACK PUDDING
1903
Oil, 101 × 81 cm.
Private Collection, Winterthur
18. THE EXCISE OFFICE
Toward 1900
Oil, 37.5 × 32.5 cm.
The Courtauld Institute, London
19. PORTRAIT OF MISS M.
1896
Oil, 150 × 97 cm.
Ex-Pablo Picasso Collection, France
20. LANDSCAPE WITH ANGLERS
Toward 1897
Oil, 23.5 × 37 cm.
Private Collection, Charpentier Gallery,
Paris
21. STREET IN THE CITY OUTSKIRTS
Toward 1898
Oil, 32 × 40 cm.
A. Max Weitzenhoffer Jr. Collection,
Findlay Galleries, New York
22. STILL LIFE WITH COFFEE-POT
1906—1907

Oil, 38 × 46 cm.
Mattioli Collection, Milan
23. CHILD WITH DOLL
1905
Oil, 66.5 × 51 cm.
Walter Collection, Paris
24. ALLEY IN A GARDEN
1905—1908
Private Collection
25. WINTER
1907
Oil, 40 × 52 cm.
Private Collection, Neuilly-sur-Seine
26. LANDSCAPE ON THE SHORES OF
THE MARNE
1898
Oil, 29.5 × 34.5 cm.
Museum of Fine Arts, Houston
27. SPRING AT ALFORTVILLE
1906
Oil, 40 × 52 cm.
Private Collection
28. THE WEDDING
1905
Oil, 163 × 114 cm.
Walter Collection, Paris
29. ALLEY IN ST.-CLOUD PARK
Toward 1903
Oil, 46.2 × 37.6 cm.
Städtische Gallerie, Frankfurt am Main
30. GRAZING FIELD
Toward 1904
Oil
Private Collection
31. THE LION BEING HUNGRY POUN-
CES UPON THE ANTELOPE
The Lion and Antelope:
*The Lion being hungry pounces upon the
antelope and devours it; the panther anxiously
awaits for its share. Birds of prey have
already wrenched a hulk of flesh, while the
poor animal sheds a tear! Sunset.*
1905
Oil, 200 × 300 cm.
Private Collection, Switzerland
32. THE SNAKE CHARMER
1907
Oil, 167 × 189 cm.
The Louvre, Paris
33. THE QUARRY
Toward 1908
Oil, 47.5 × 55.5 cm.
Private Collection, New York
34. ANGLERS, WITH AIRPLANE
1907—1908
Oil, 46 × 55 cm.
Walter Collection, Paris
35. VIEW OF THE SÈVRES BRIDGE
AND THE HILLS ROUND CLAMART,
ST.-CLOUD AND BELLEVUE
1908
Oil, 80 × 102 cm.,
Pushkin Museum, Moscow
36. THE VIADUCT IN AUTEUIL
Toward 1907
Oil, 85 × 115 cm.
Rivan Collection, Vidauban
37. LIBERTY INVITING ARTISTS TO
PARTICIPATE IN THE 22ND
EXHIBITION OF THE "INDÉPEN-
DANTS"
1906

Oil, 175 × 118 cm.
Kunsthalle, Hamburg

38. EXOTIC LANDSCAPE WITH TIGERS AND HUNTERS
Toward 1907
Oil, 59.5 × 73.5 cm.
Private Collection, Paris

39. WOMAN IN AN EXOTIC FOREST
Toward 1907
Oil, 99.5 × 81 cm.
The Barnes Foundation, Merion, Penn.

40. FLAMINGOS
1907
Oil, 113 × 162 cm.
Payson Collection, New York

41. VIRGIN FOREST AT SUNSET. A NEGRO ATTACKED BY A LEOPARD
1907
Oil, 114 × 162.5 cm.
Kunstmuseum, Basle

42. SPRING IN THE BIÈVRE VALLEY, LANDSCAPE IN THE OUTSKIRTS OF PARIS, WITH VIADUCT
1908
Oil, 54.5 × 45 cm.
Metropolitan Museum of Art, New York

43. THE PORTRAIT OF PIERRE LOTI
(so-called)
1906
Oil, 61 × 50 cm.
Kunsthaus, Zürich

44. THE SOCCER PLAYERS
1908
Oil, 100.5 × 80.5 cm.
Solomon R. Guggenheim Museum, New York

45. PEOPLE STROLLING IN A PARK
1908
Oil, 46 × 55 cm.
Walter Collection, Paris

46. GATHERING BANANAS
1907
Oil, 38 × 46 cm.
Paul Mellon Collection, Upperville

47. EVE
1906—1907
Oil, 61 × 46 cm.
Kunsthalle, Hamburg

48. ALLEY IN MONTSOURIS PARK
1905—1908
Oil, 74.5 × 47 cm.
Private Collection, New York

49. UNCLE JUNIOT'S DOG-CART
1908

Oil, 97 × 129 cm.
Walter Collection, Paris

50. JUNGLE: TIGER ATTACKING A BUFFALO
1908
Oil, 172 × 191.5 cm.
Cleveland Museum of Art, Ohio

51. THE WATERFALL
1910
Oil, 115 × 151 cm.
The Art Institute of Chicago

52. LOTUS-BLOSSOMS
1910
Oil, 48 × 37 cm.
Gattlen Gallery, Lausanne

53. THE DREAM
(Yadwigha in sweet slumber, dreams a beautiful dream | She hears the sounds of a bagpipe played by a kind magician | Whilst the moon casts the shade of green trees over the flowers | Fierce serpents listen | To the joyful tunes of the pipe)
1910
Oil, 204.5 × 298.5 cm.
Museum of Modern Art, New York

54. THE PORTRAIT OF JOSEPH BRUMMER
1909
Oil, 117 × 87 cm.
Kunsthalle, Hamburg

55. VIEW OF THE EIFFEL TOWER
1910
Oil, 50 × 65 cm.,
Private Collection

56. EXOTIC LANDSCAPE
1910
Oil, 129 × 162 cm.
McCormick Collection, Washington, D.C.

57. HORSE ATTACKED BY JAGUAR
1910
Oil, 90 × 116 cm.
Pushkin Museum, Moscow

58. THE CHURCH OF NOTRE-DAME
1909
Oil, 33 × 40.5 cm.
Phillips Collection, Washington, D.C.

59. MUSE INSPIRING THE POET (second version)
(Guillaume Appolinaire and Marie Laurencin)
1909
Oil, 146 × 97 cm.
Kunstmuseum, Basle.

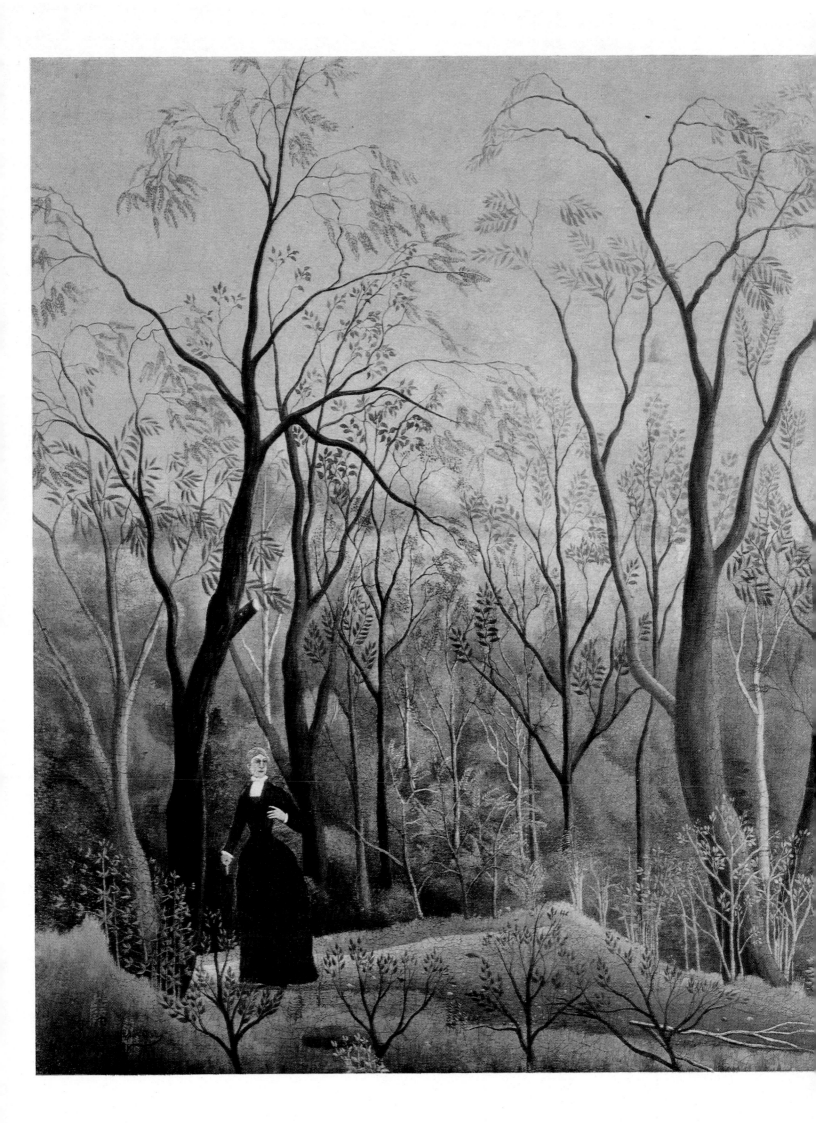

1. A Stroll in the Woods. In Expectation
←

2. Carnival Night

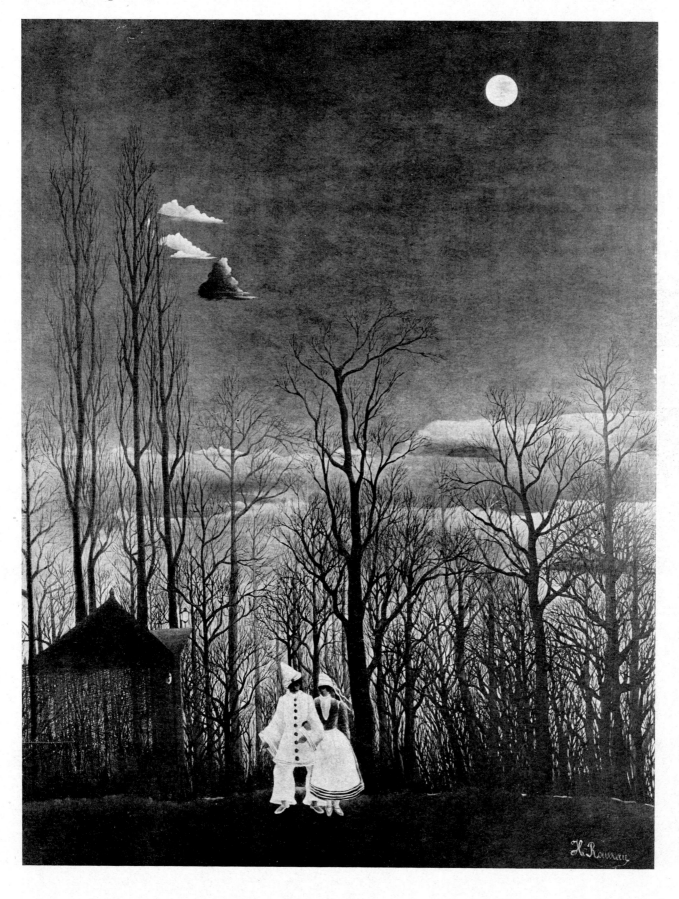

3. The Island of St. Louis, View from St. Nicholas Port, at Eventide

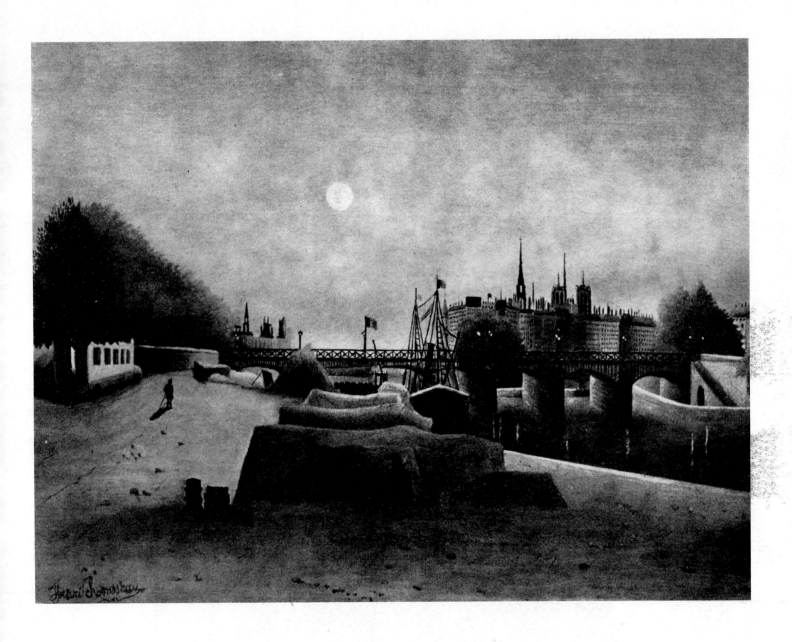

4. The War *or* The Cavalcade of Discord

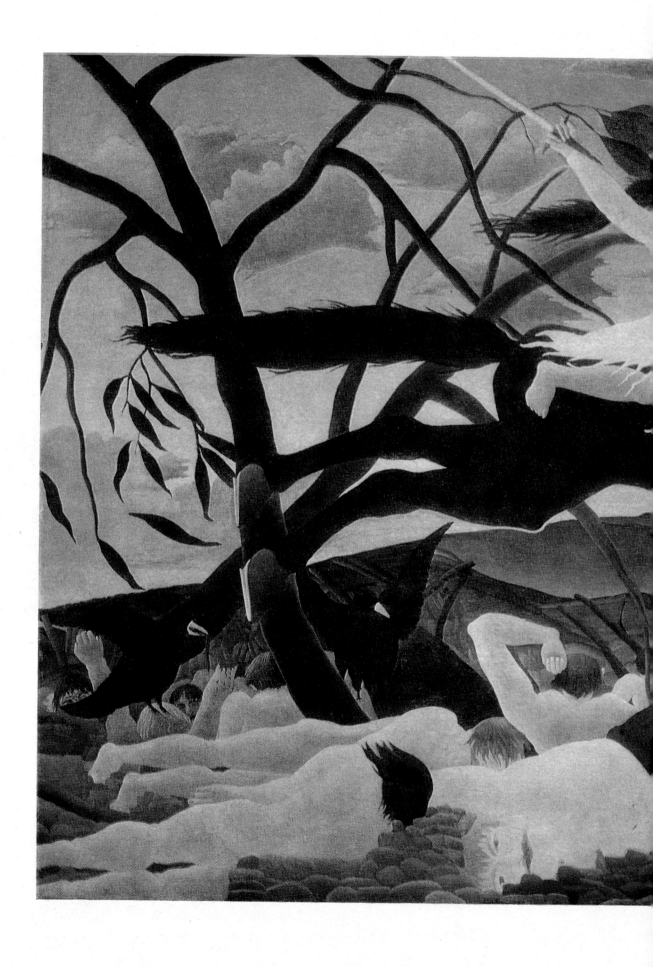

Henri Rousseau

5. Storm in the Jungle

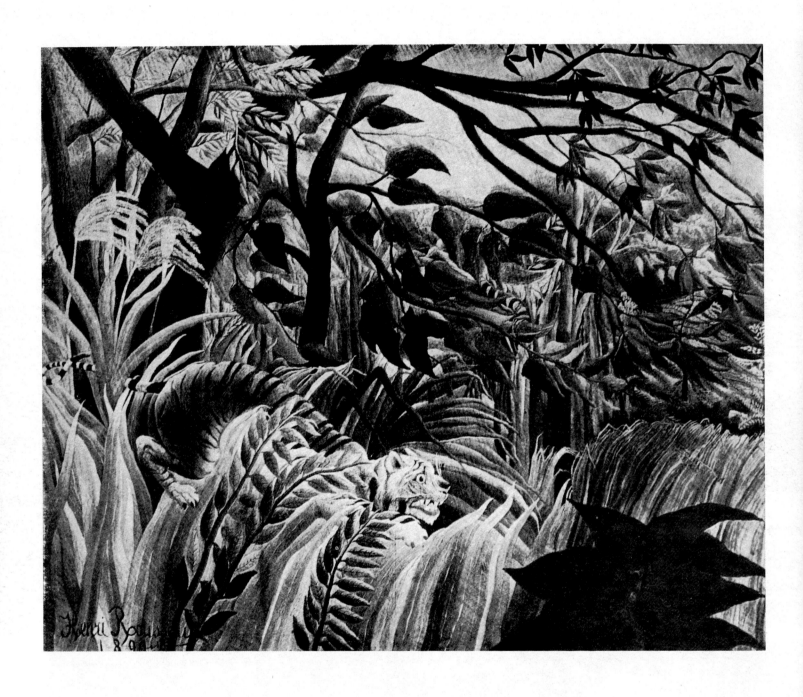

6. The Sleeping Gypsy

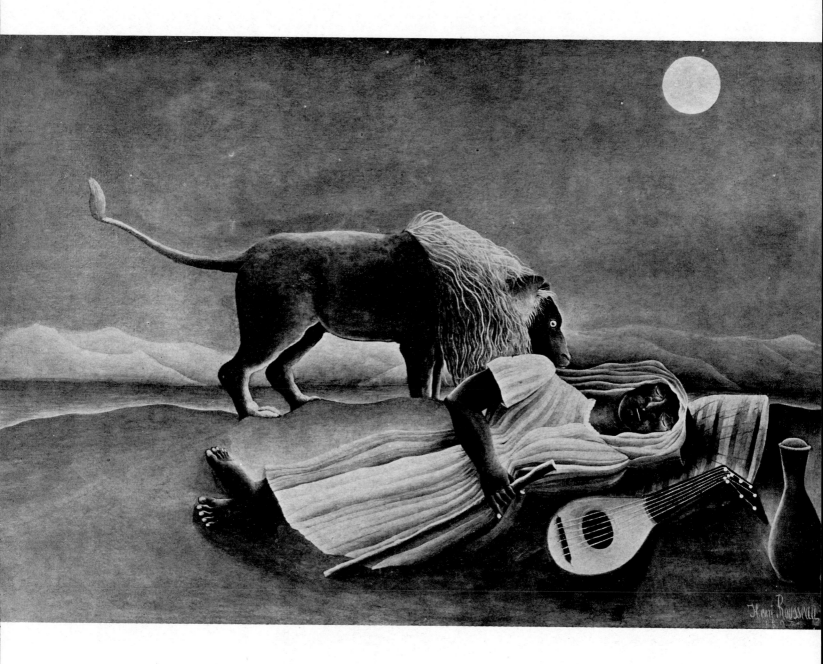

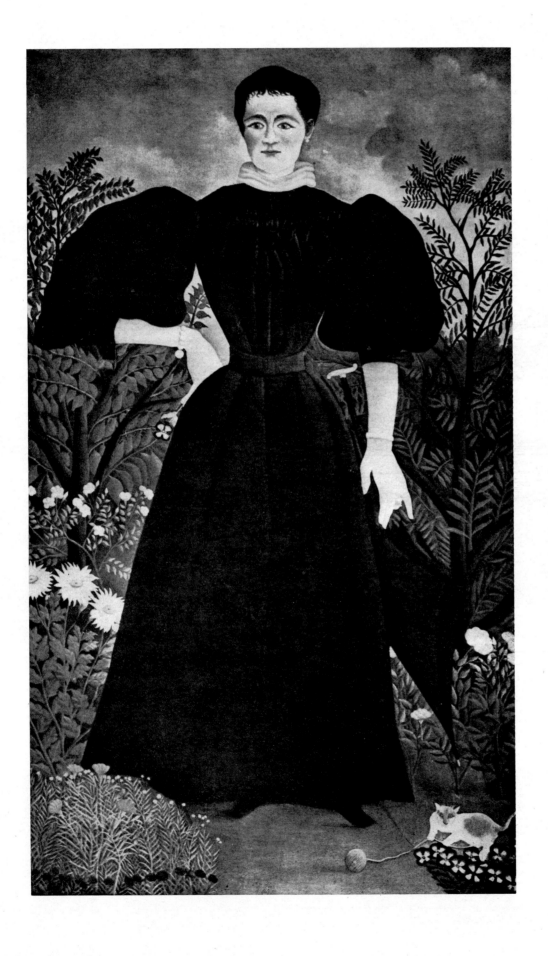

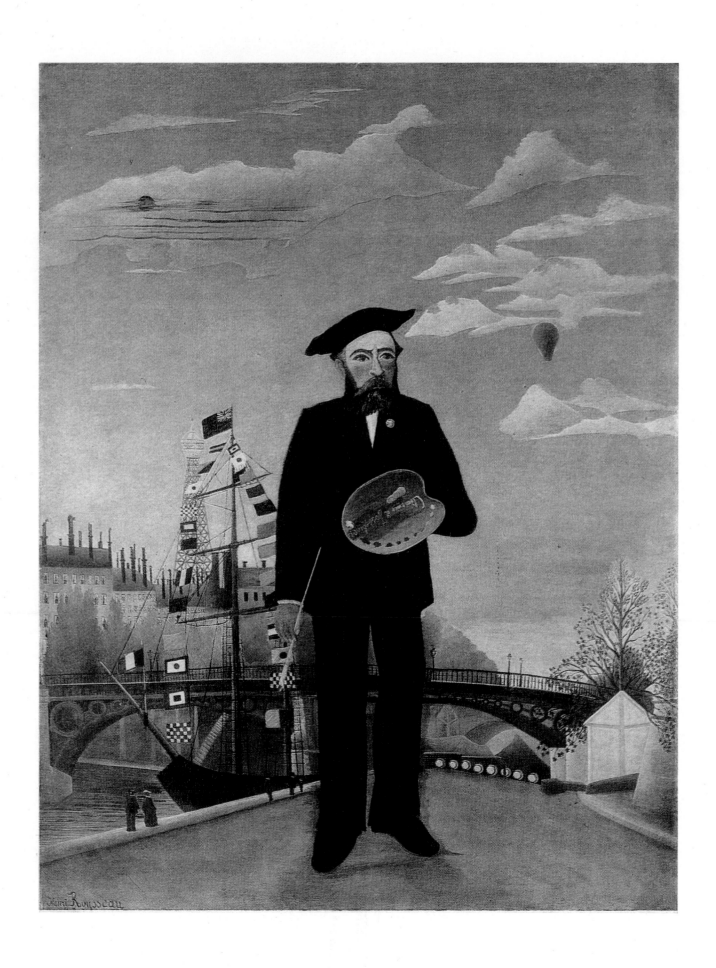

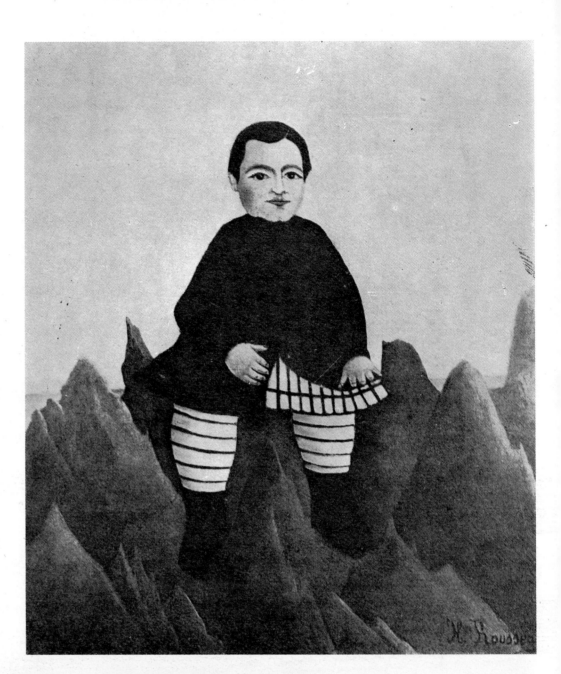

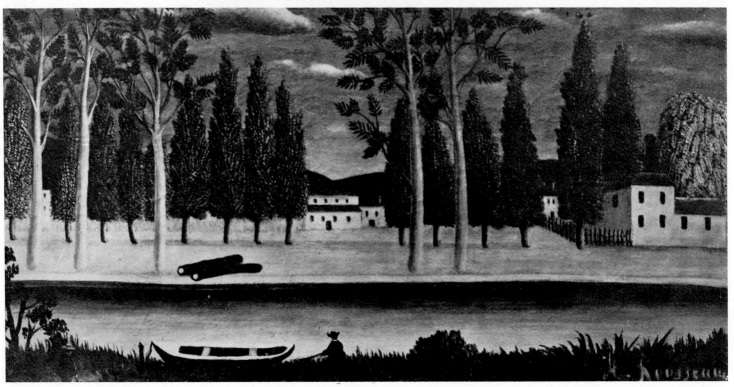

11. The Mill at Altfort

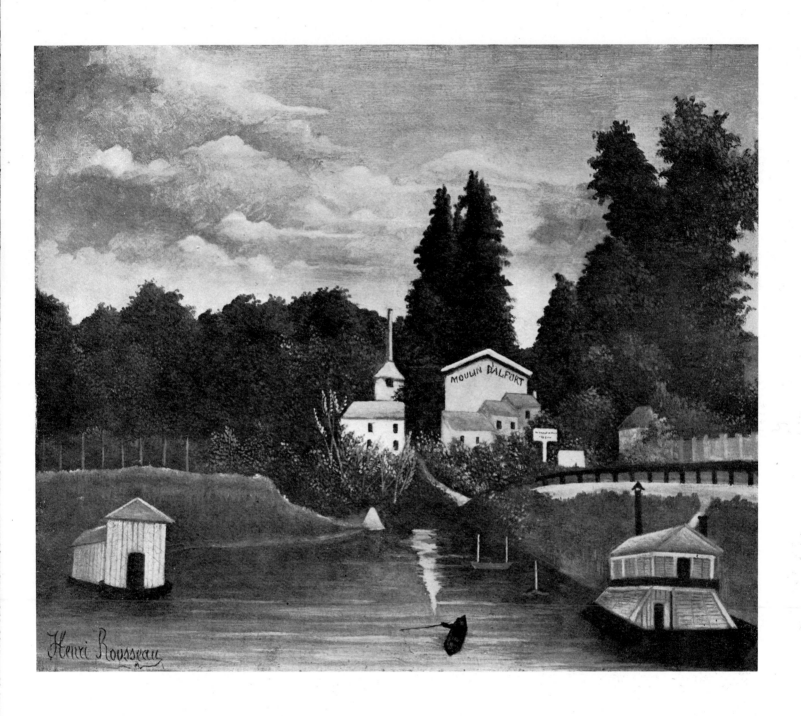

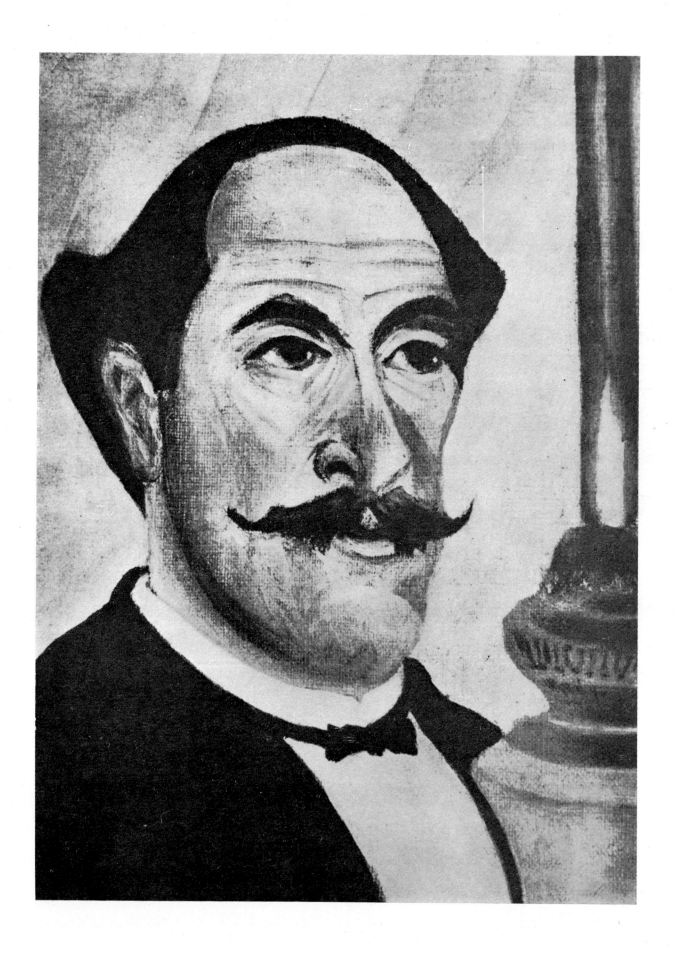

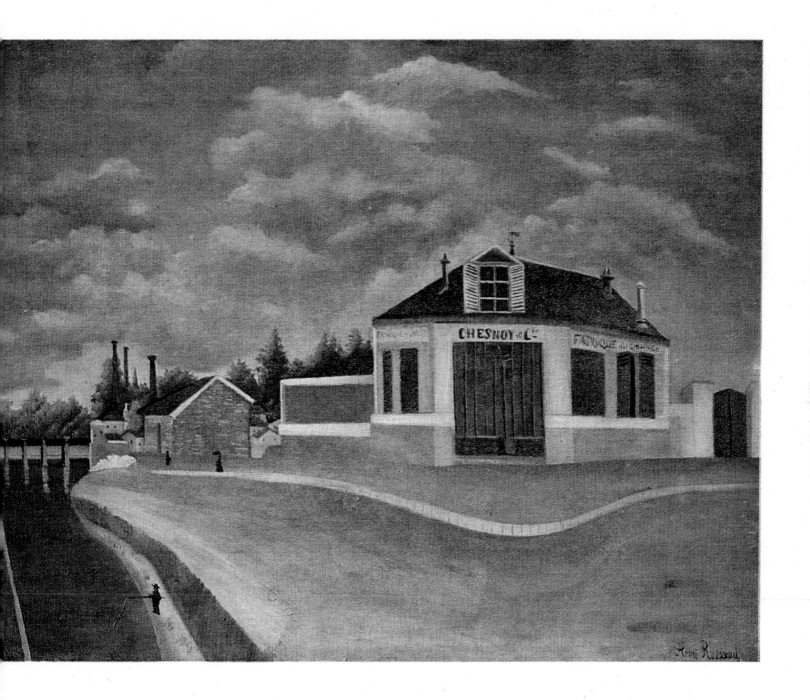

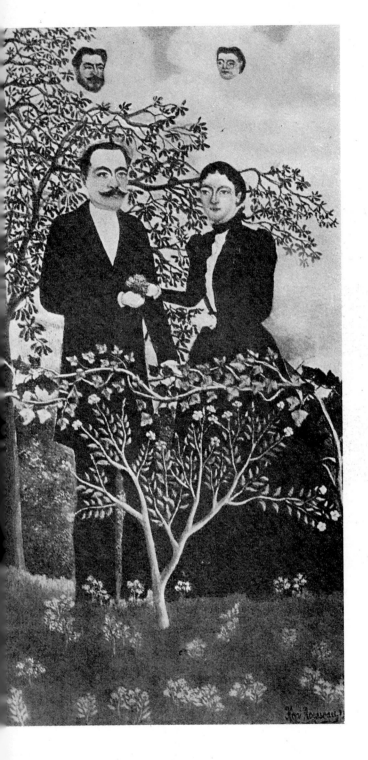

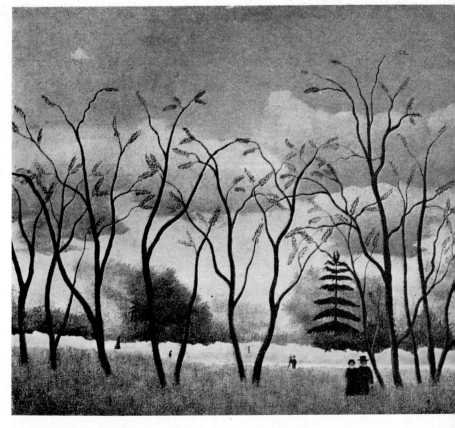

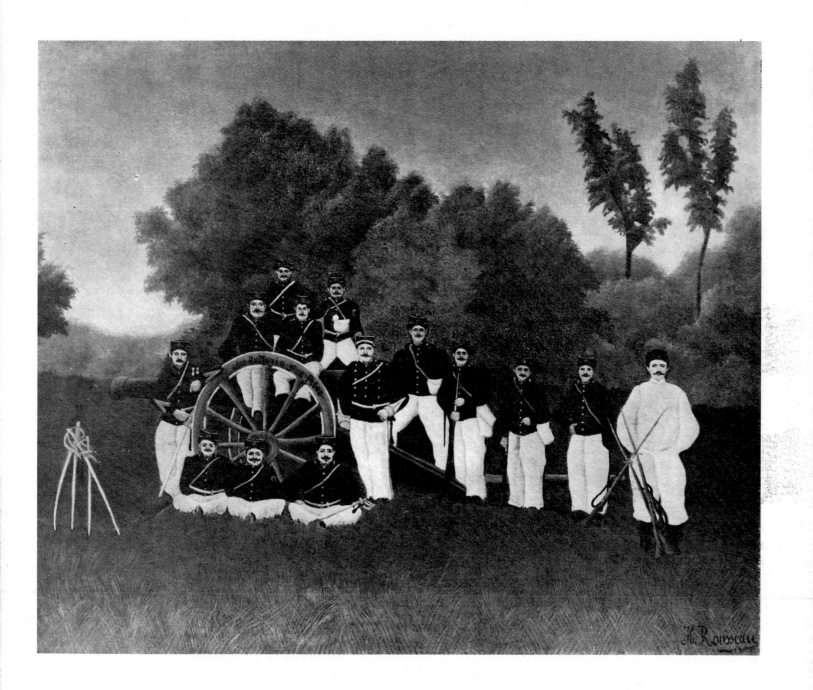

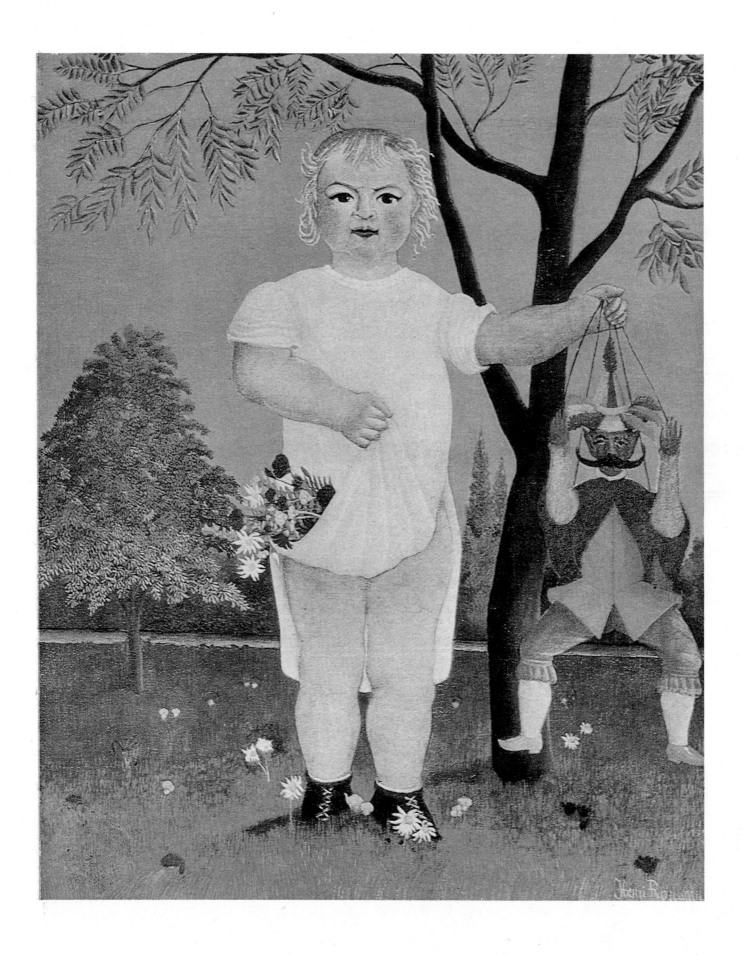

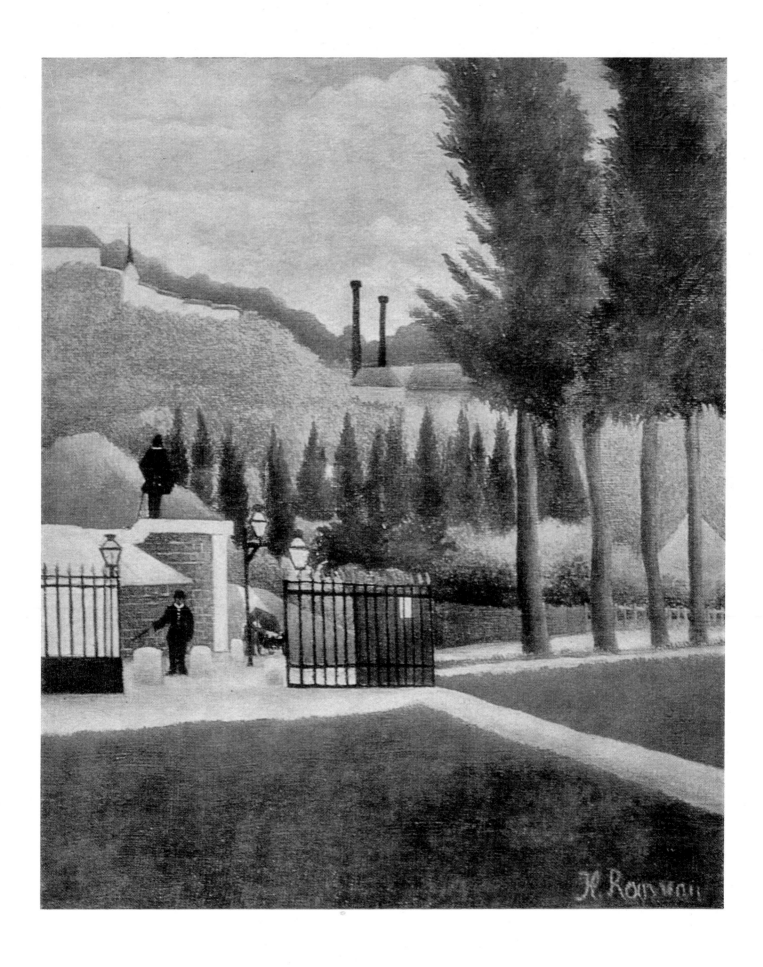

19. Portrait of Miss M.
20. Landscape with Anglers

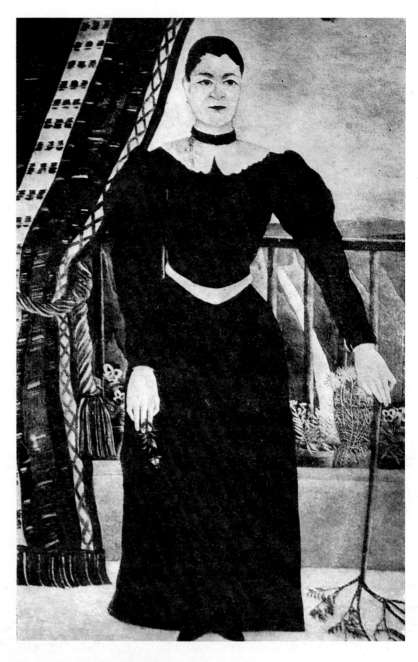

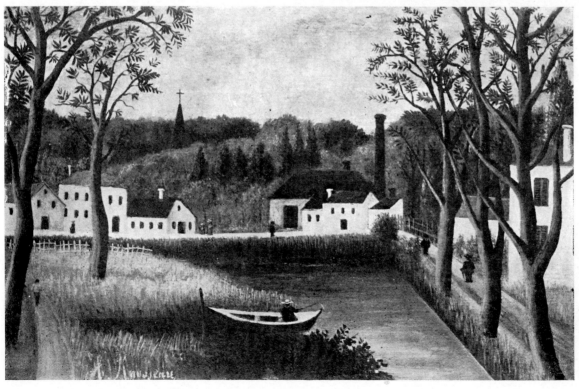

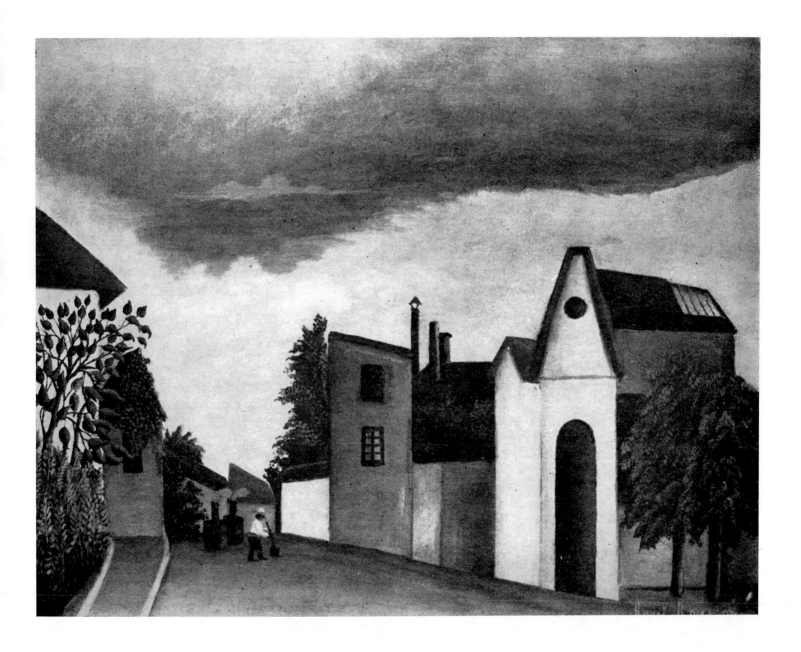

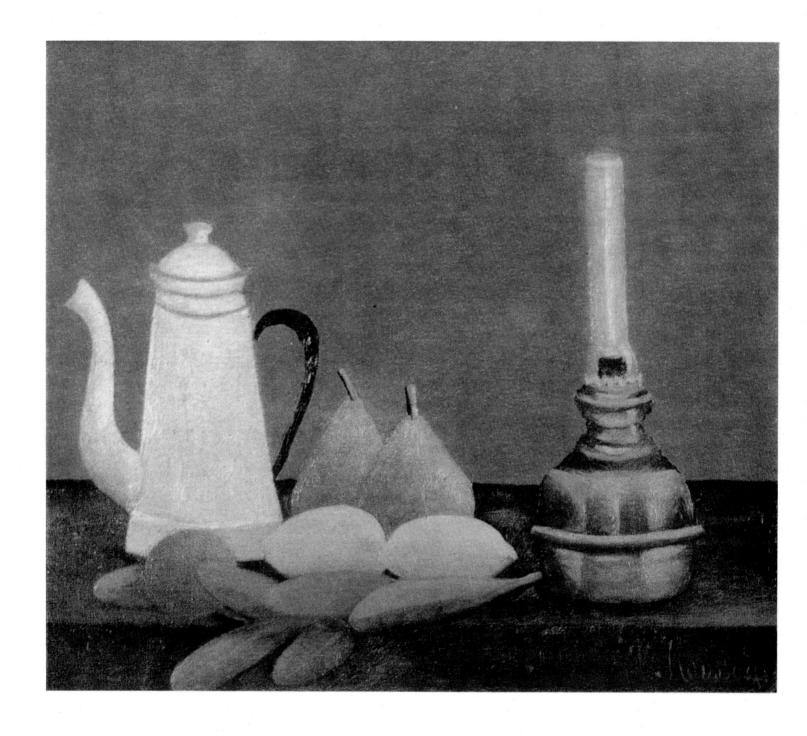

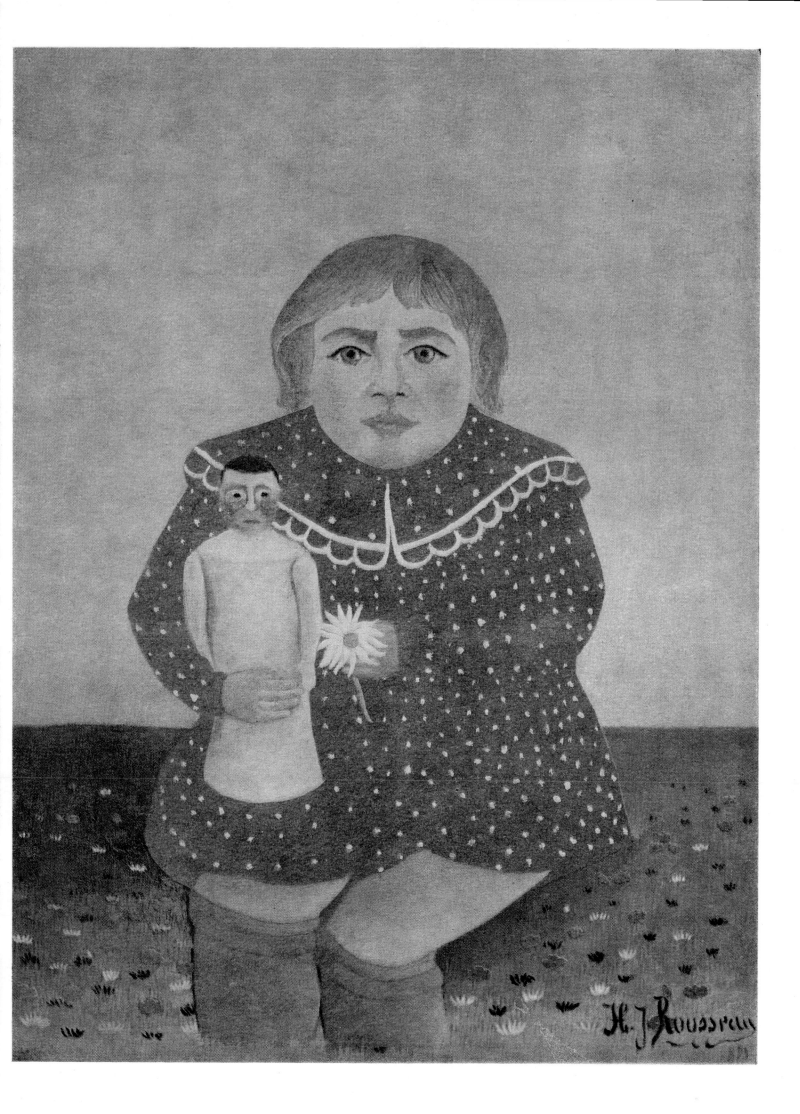

24. Alley in a Garden
25. Winter

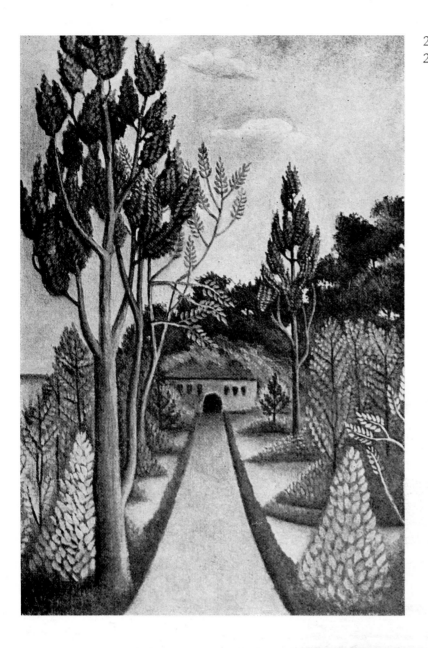

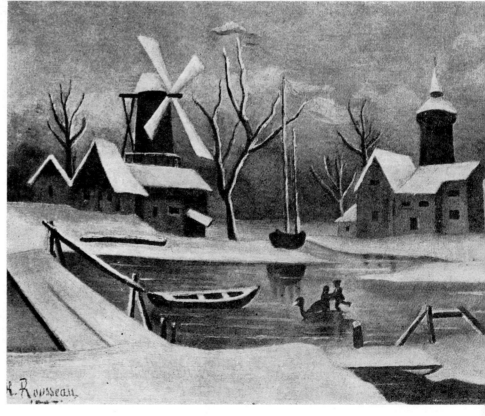

26. Landscape on the Shores of the Marne

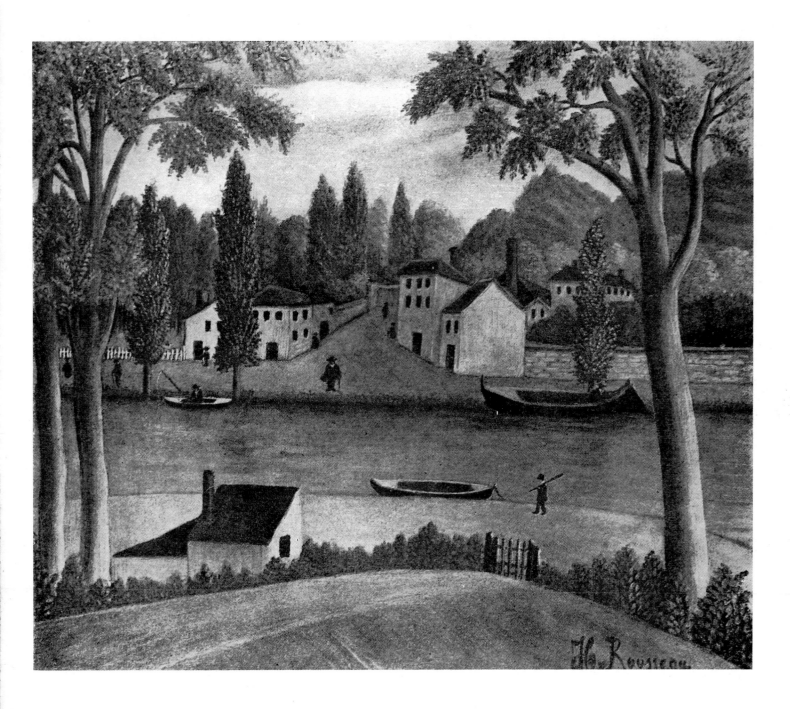

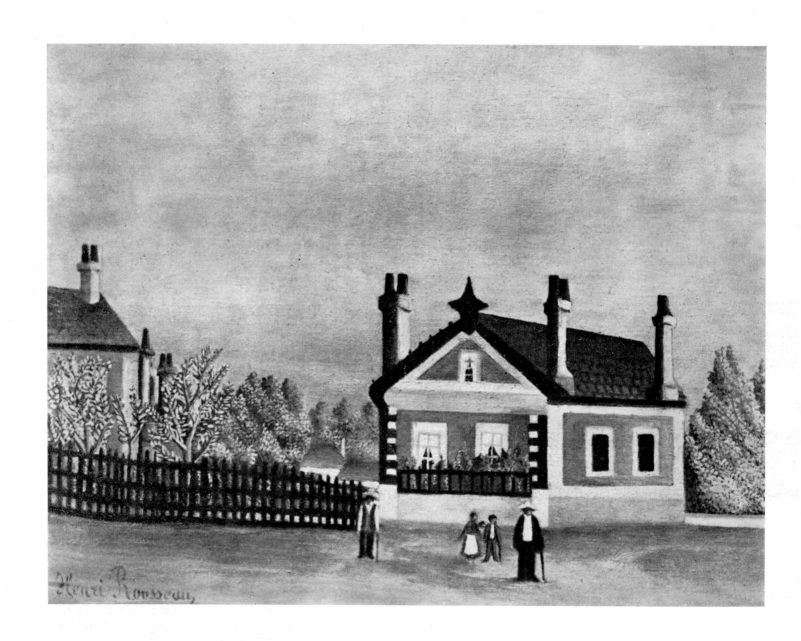

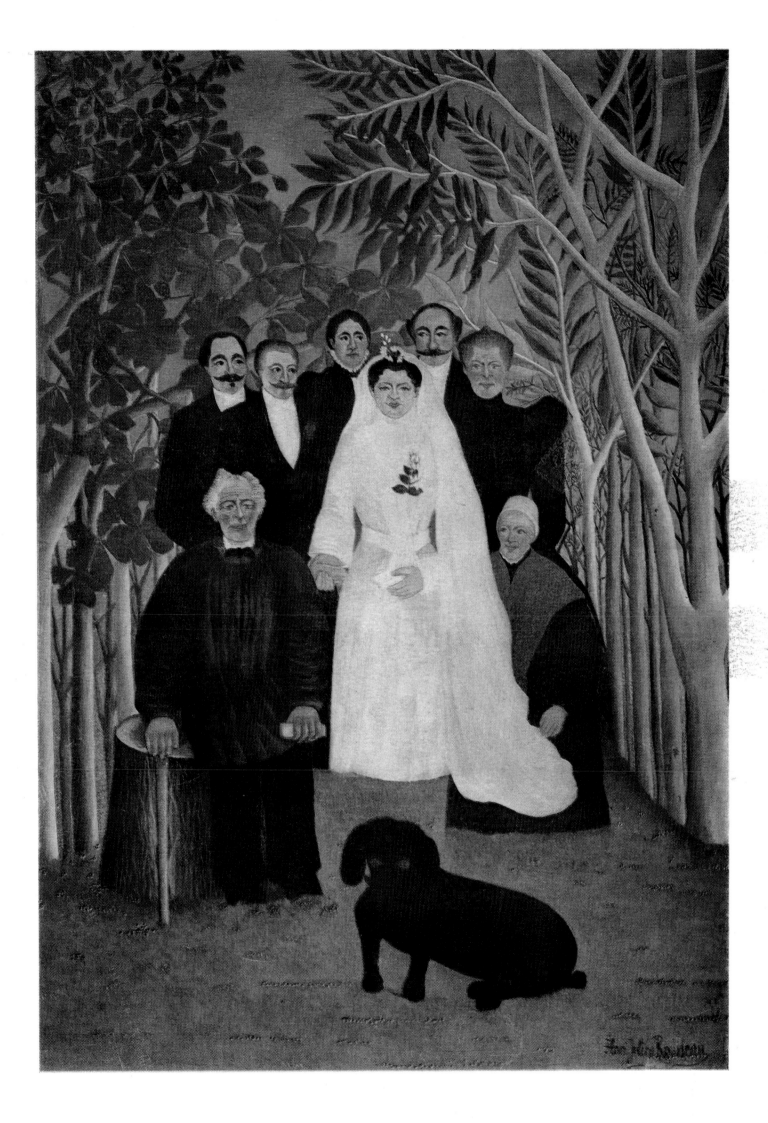

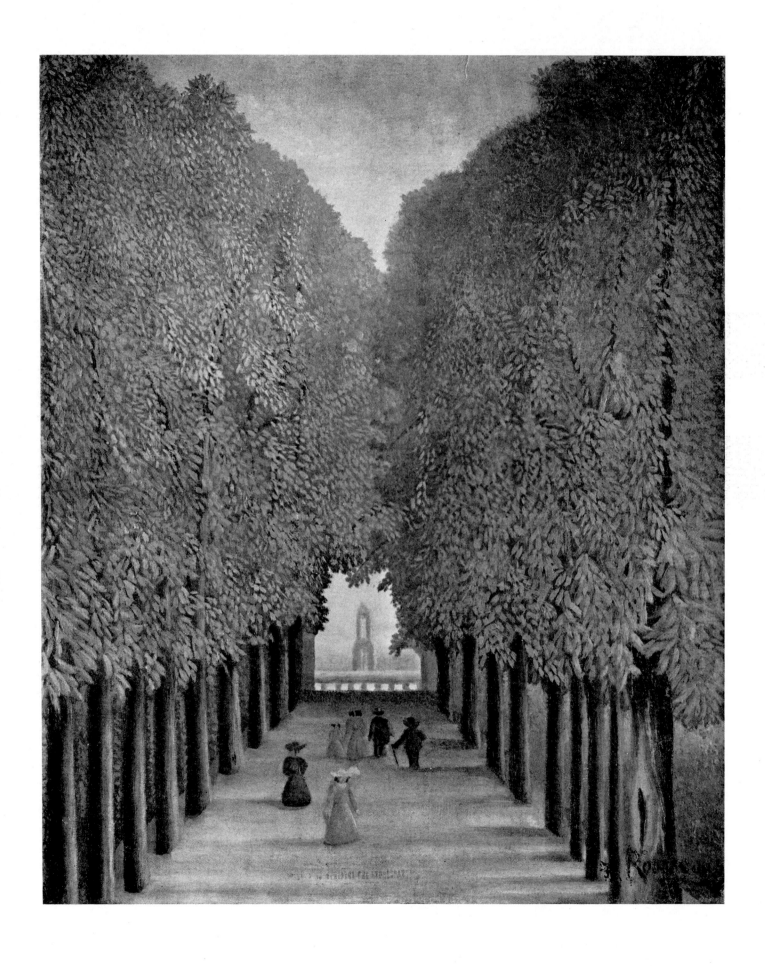

30. Grazing Field

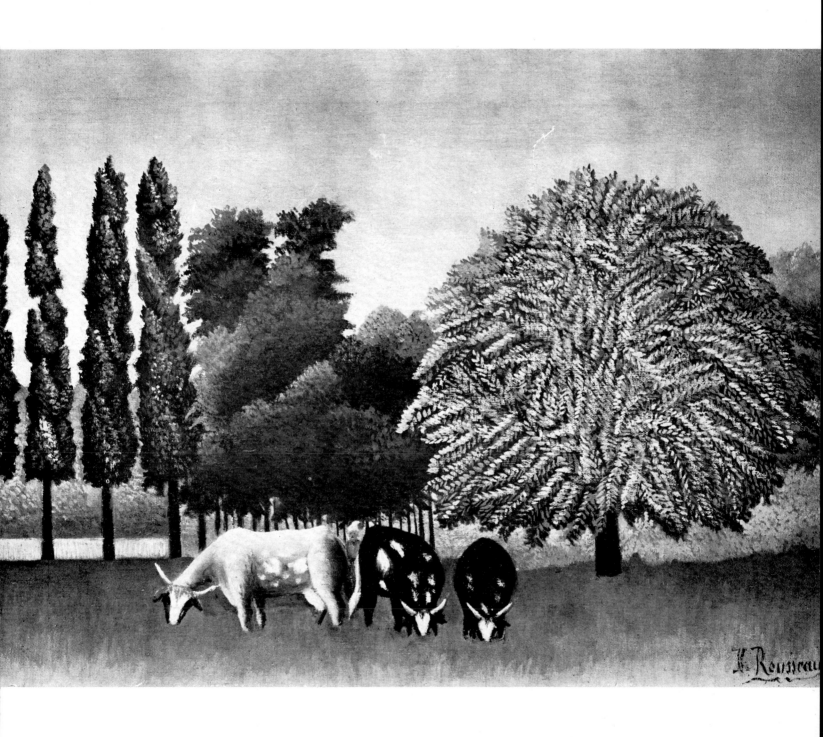

31. The Lion Being Hungry Pounces upon the Antelope

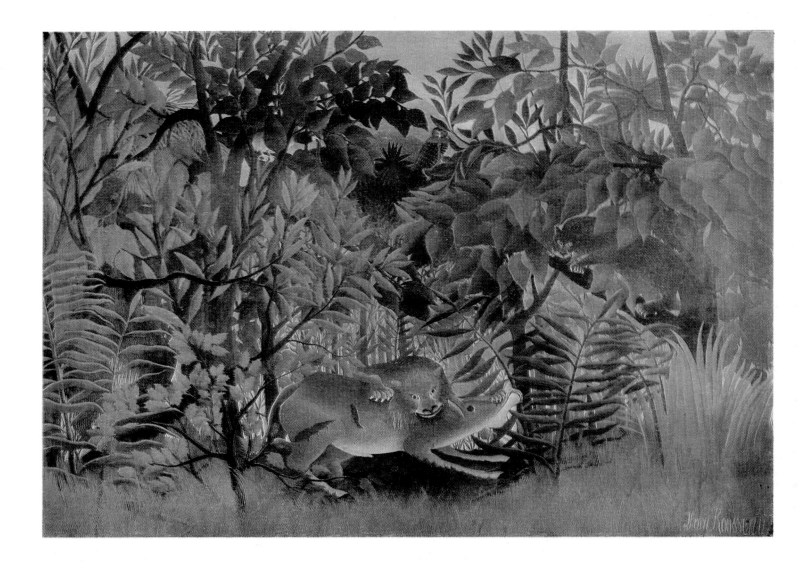

32. The Snake Charmer

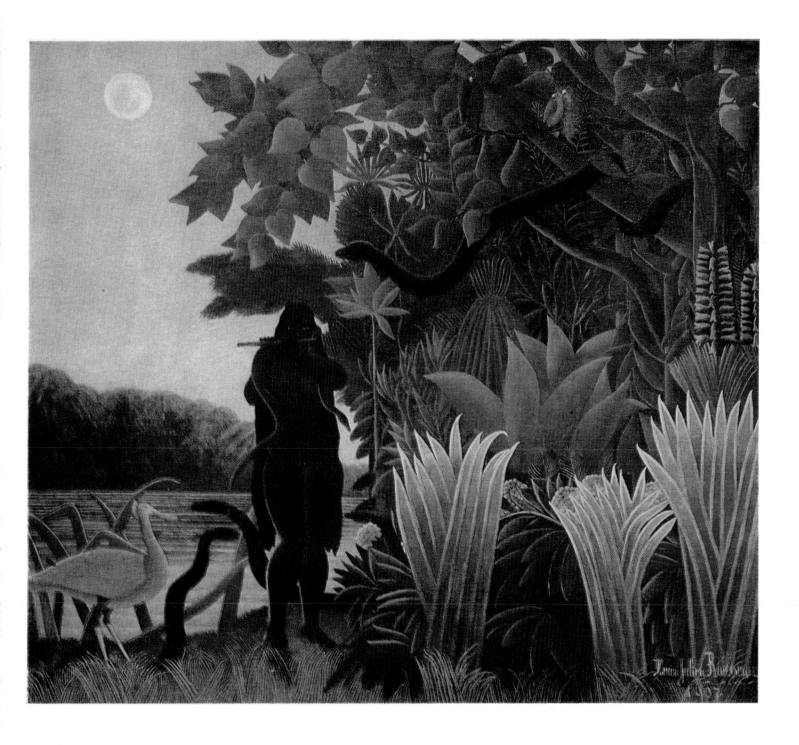

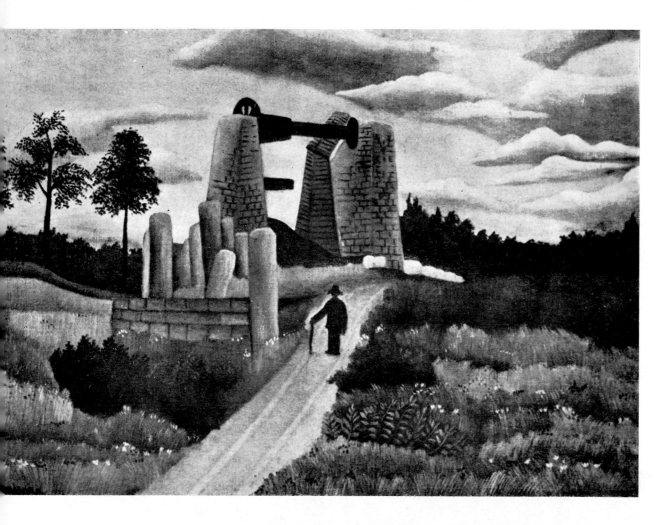

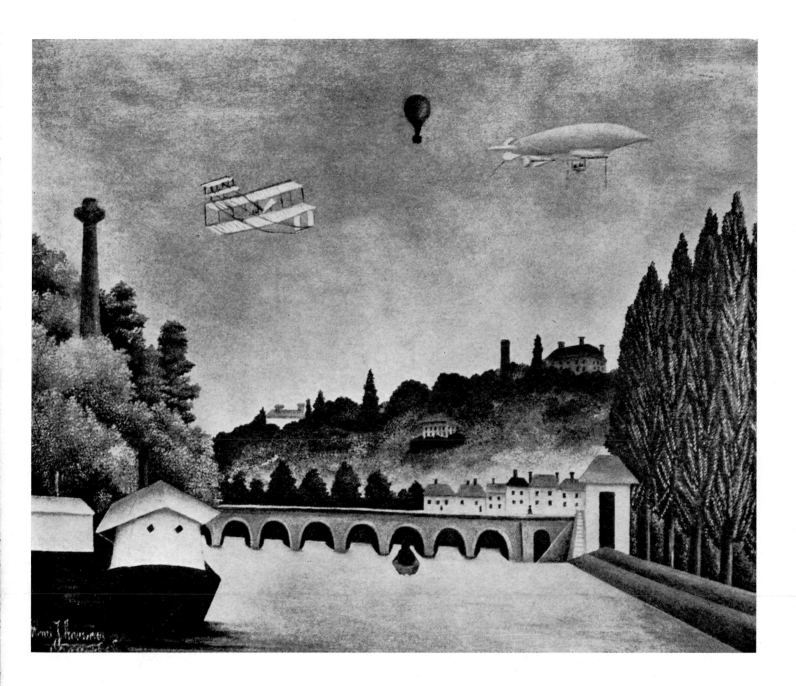

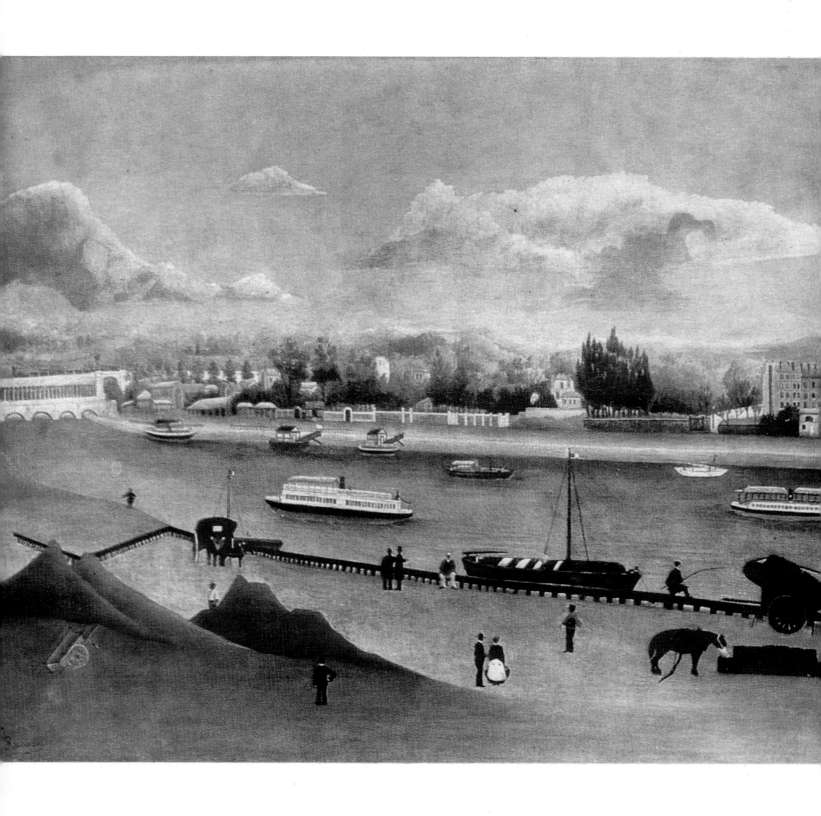

38. Exotic Landscape with Tigers and Hunters

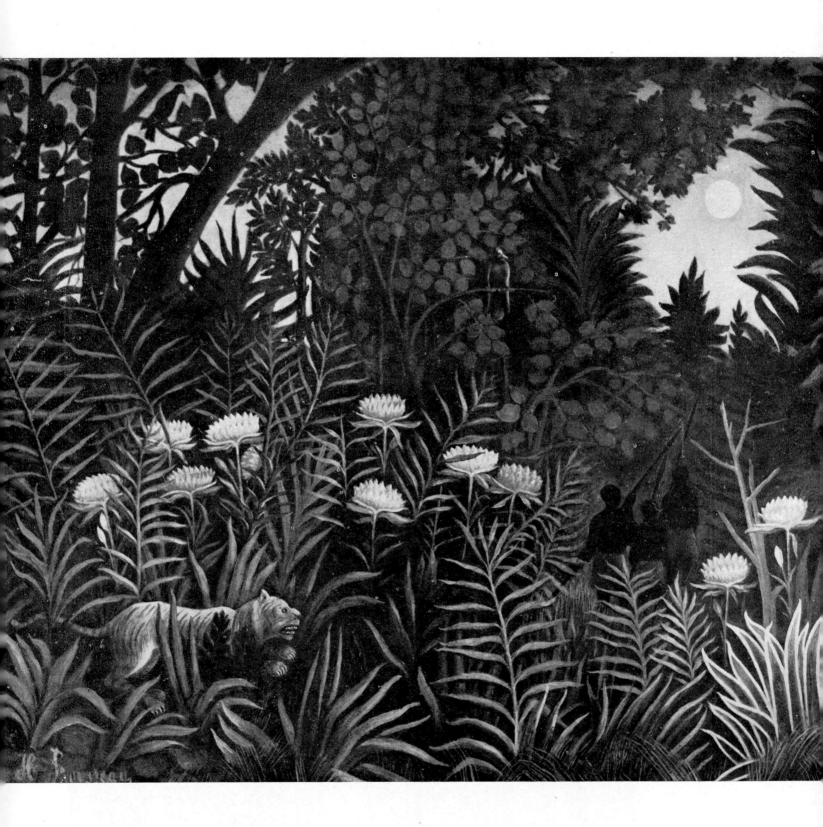

39. Woman in an Exotic Forest

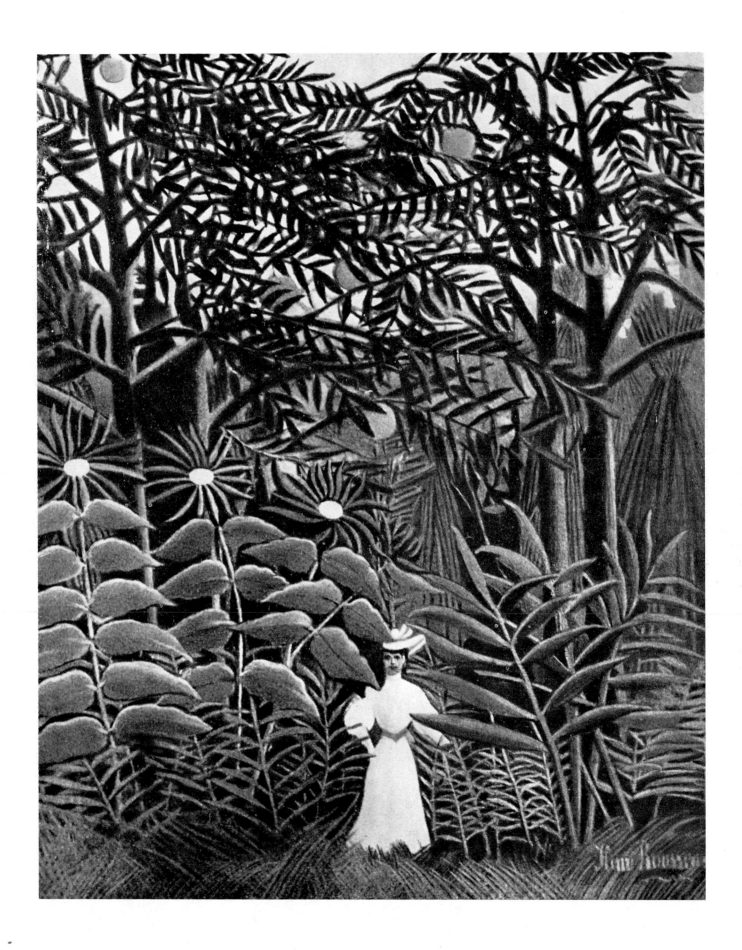

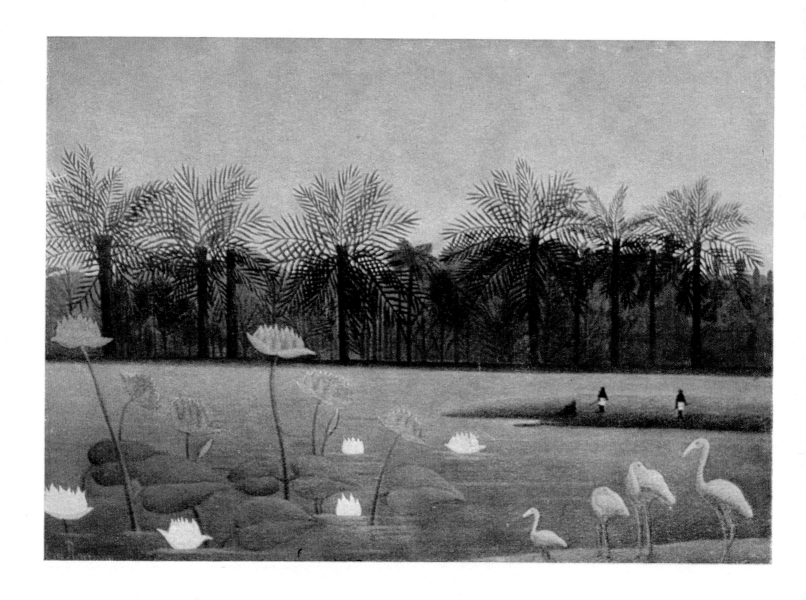

41. Virgin Forest at Sunset. A Negro Attacked by a Leopard

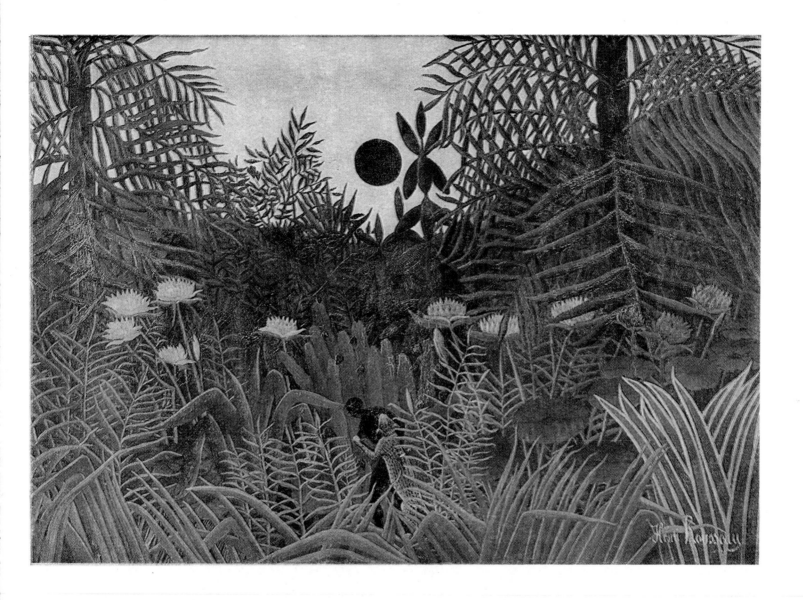

42. Spring in the Bièvre Valley, Landscape in the
Outskirts of Paris, with Viaduct

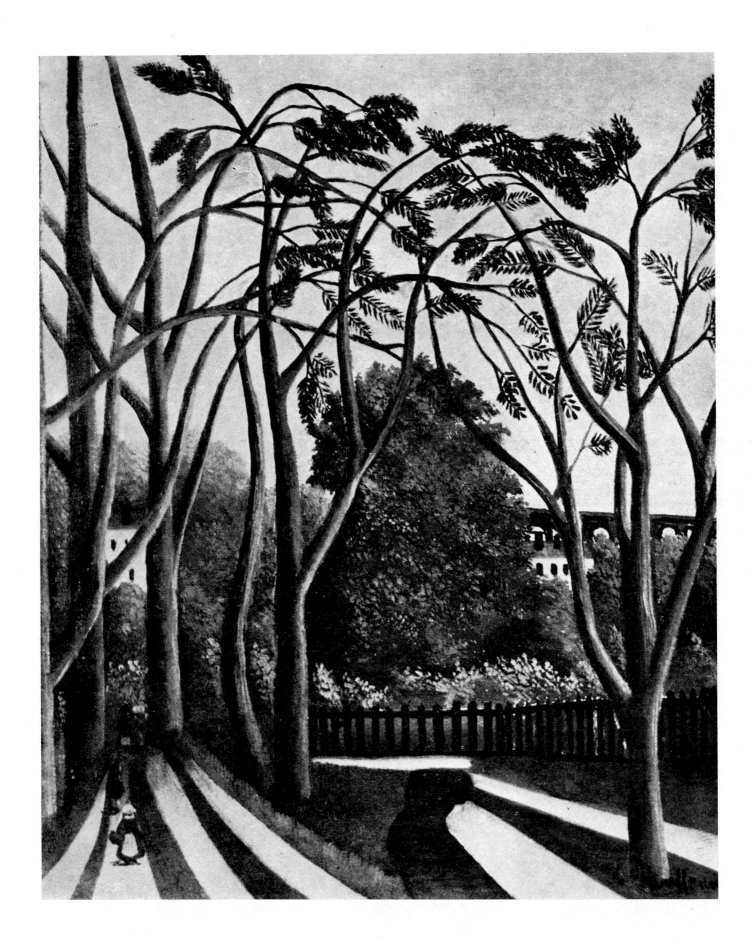

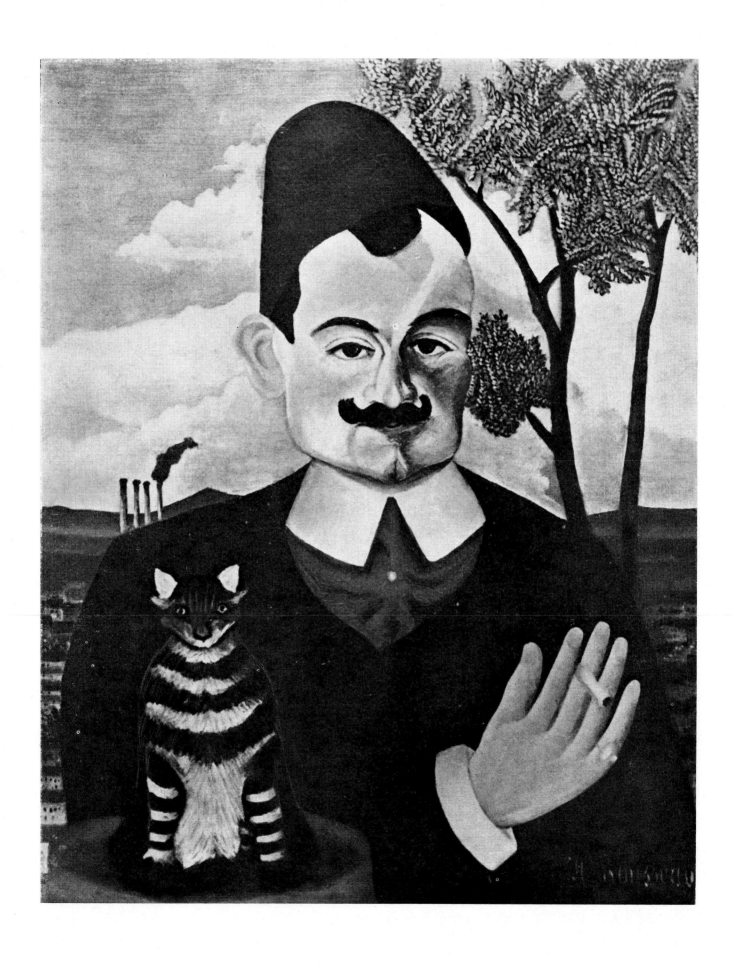

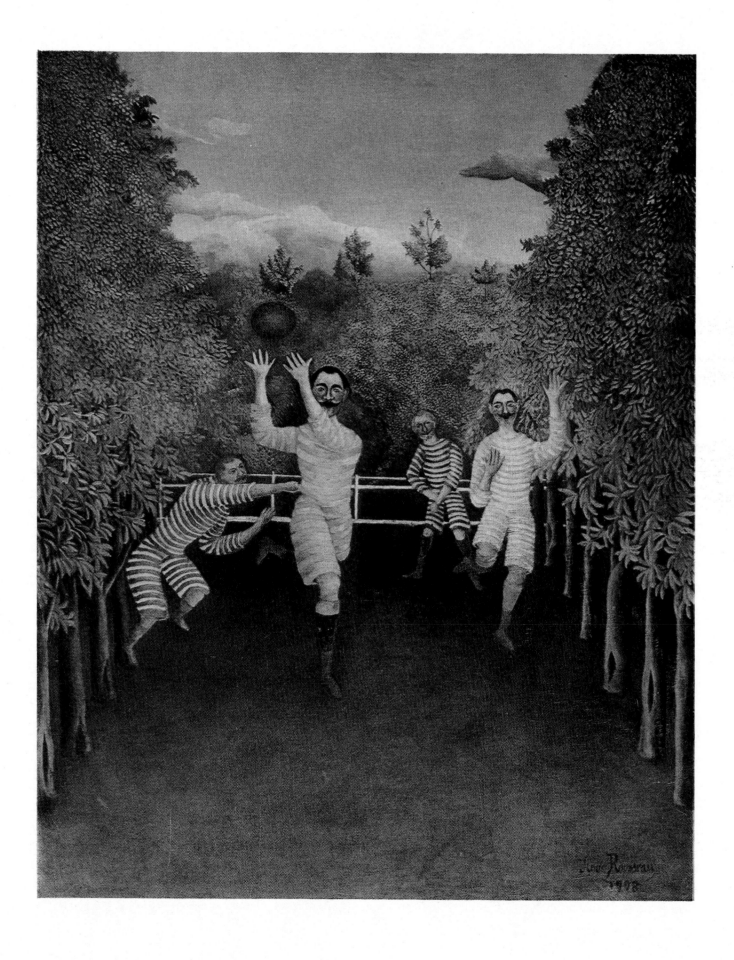

45. People Strolling in a Park

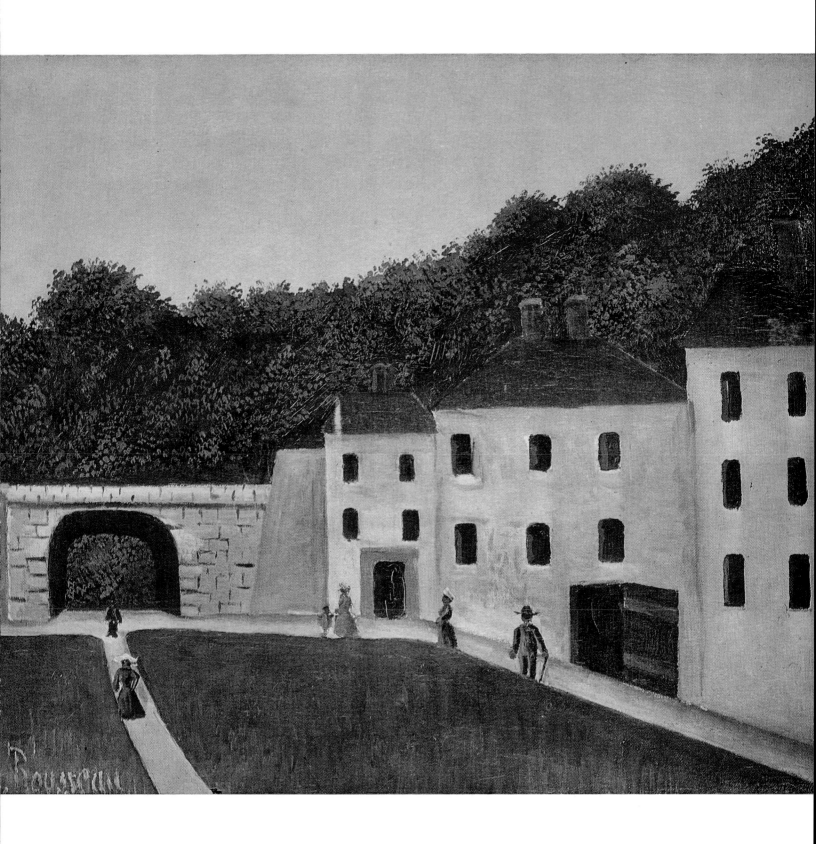

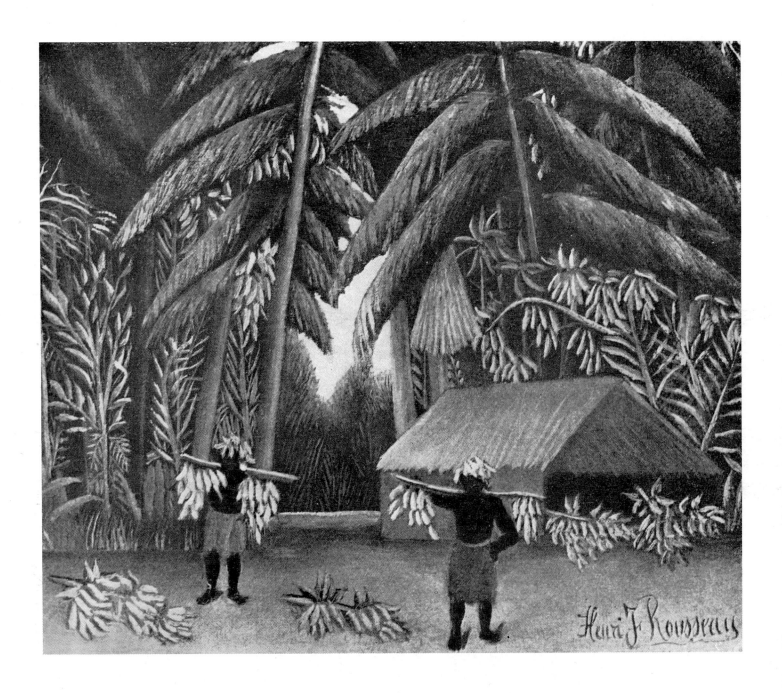

47. Eve

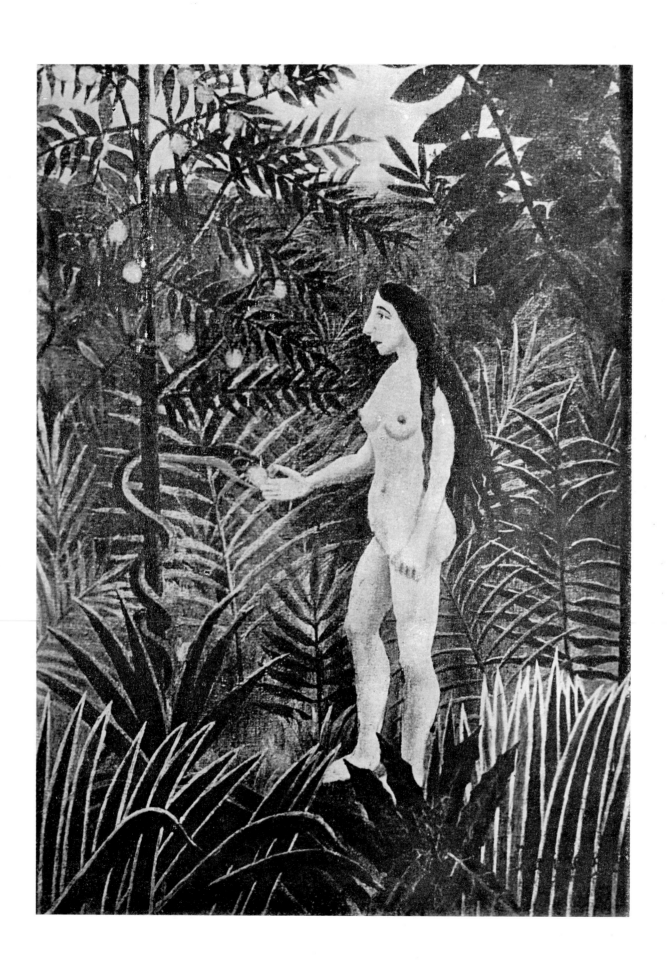

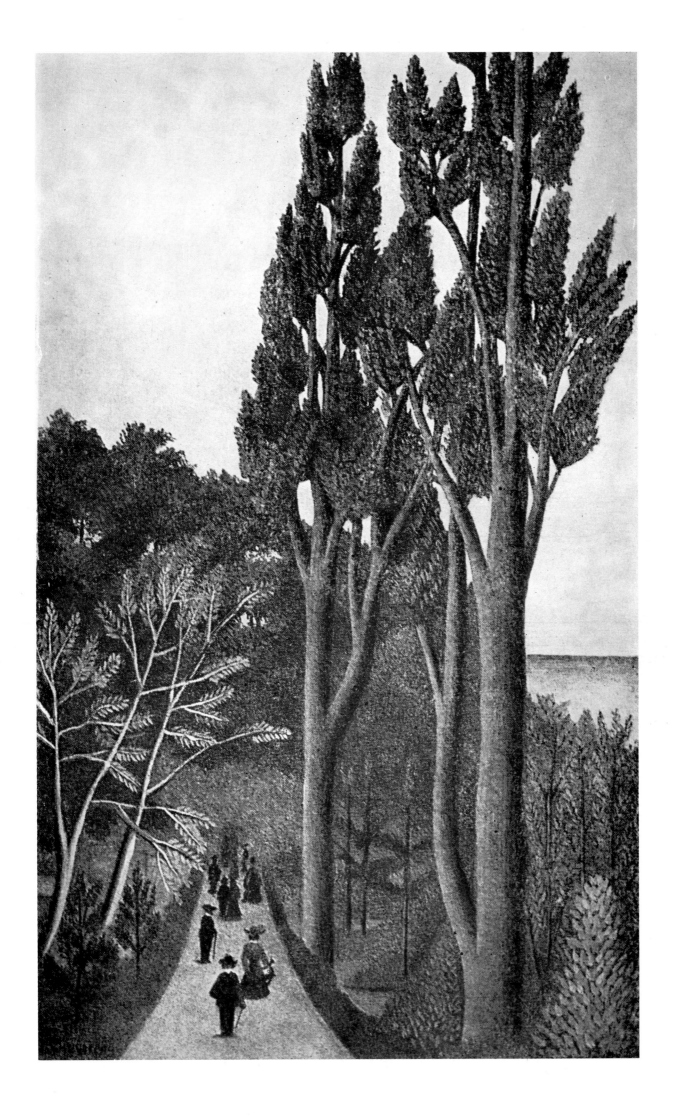

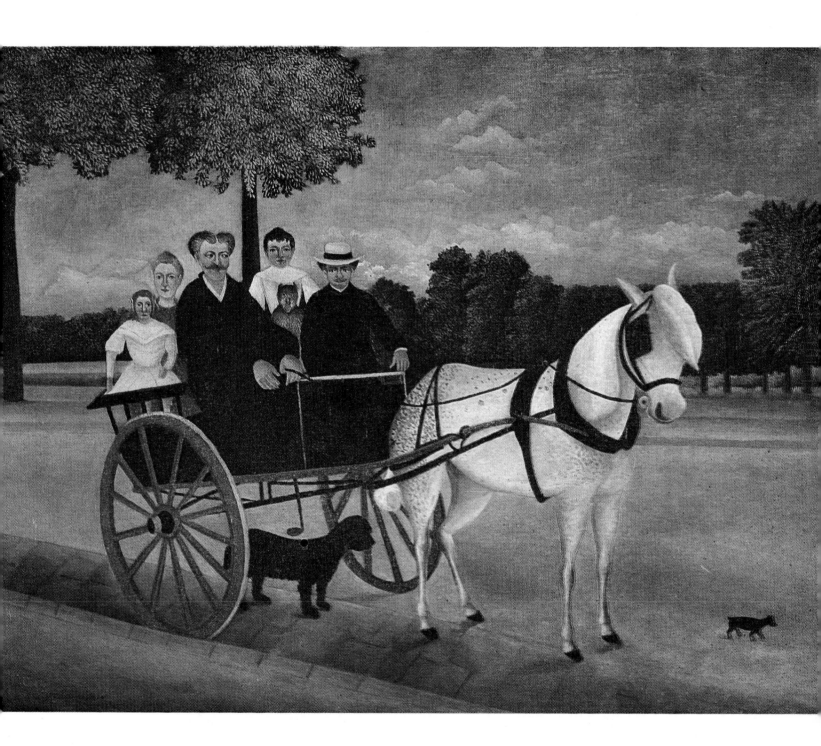

50. Jungle: Tiger Attacking a Buffalo

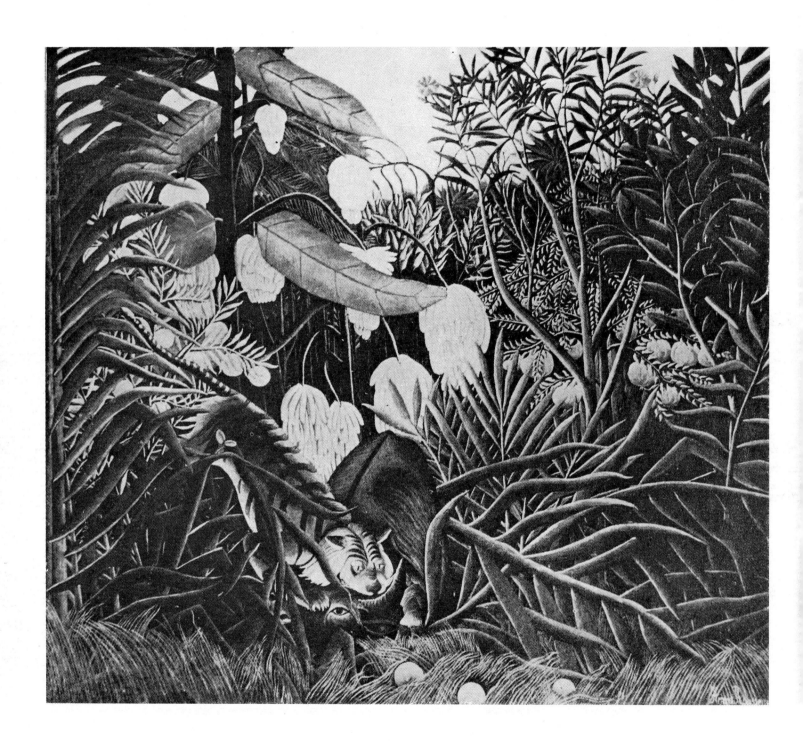

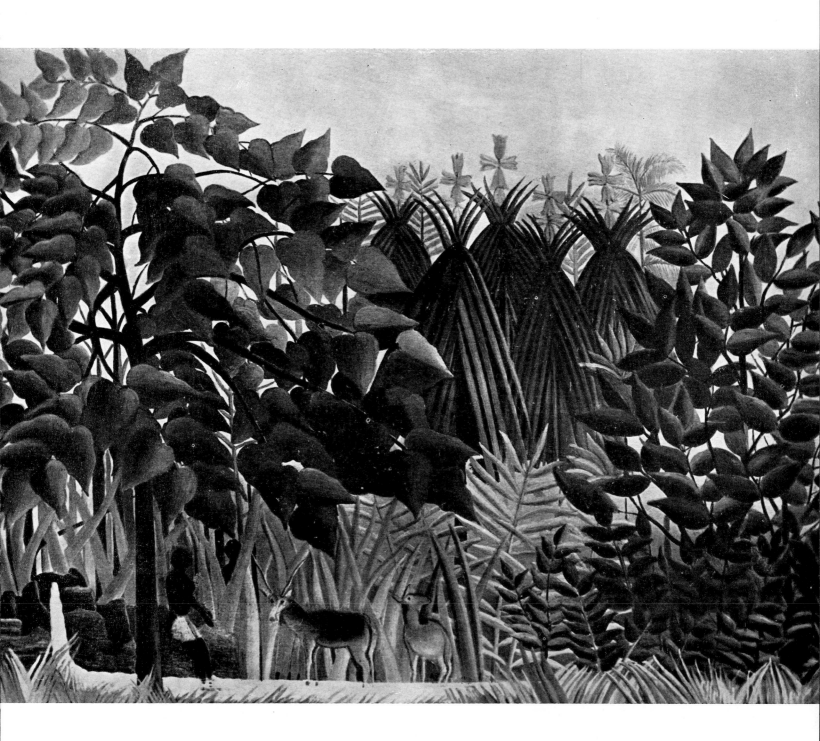

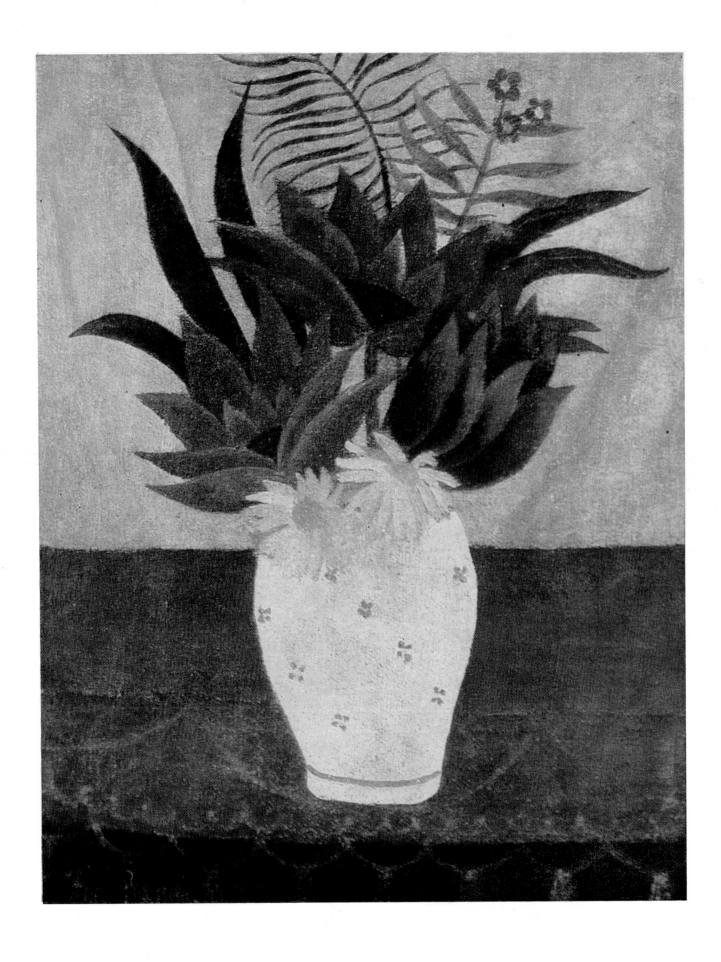

53. The Dream

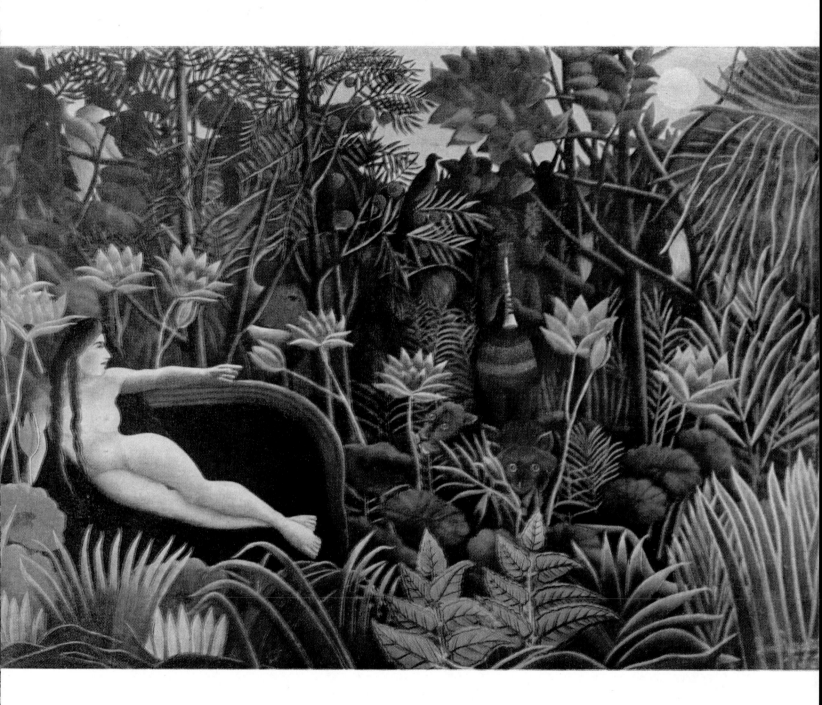

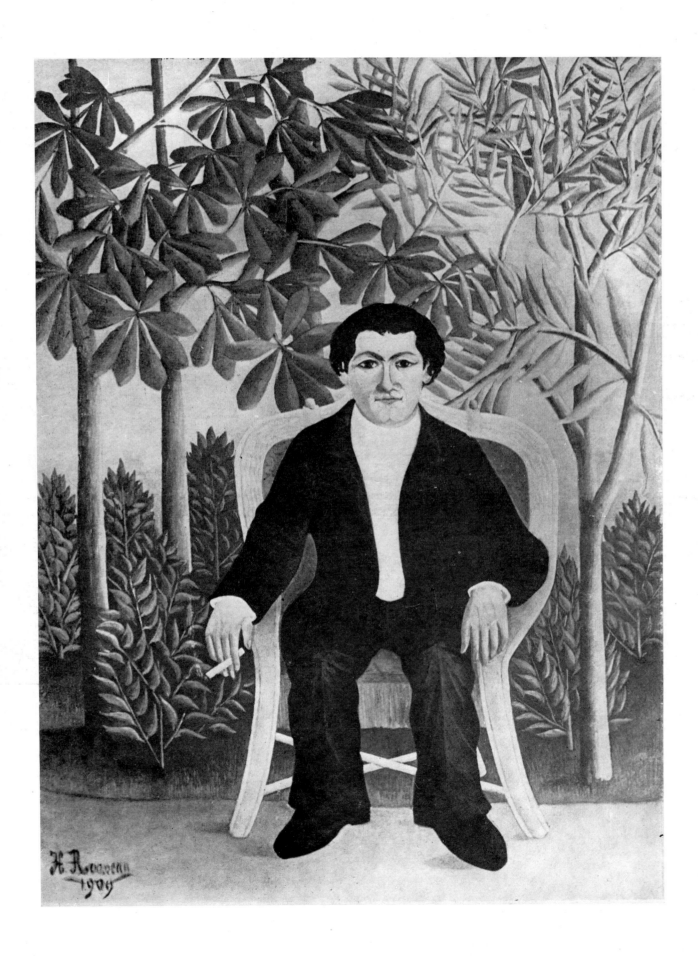

55. View of the Eiffel Tower

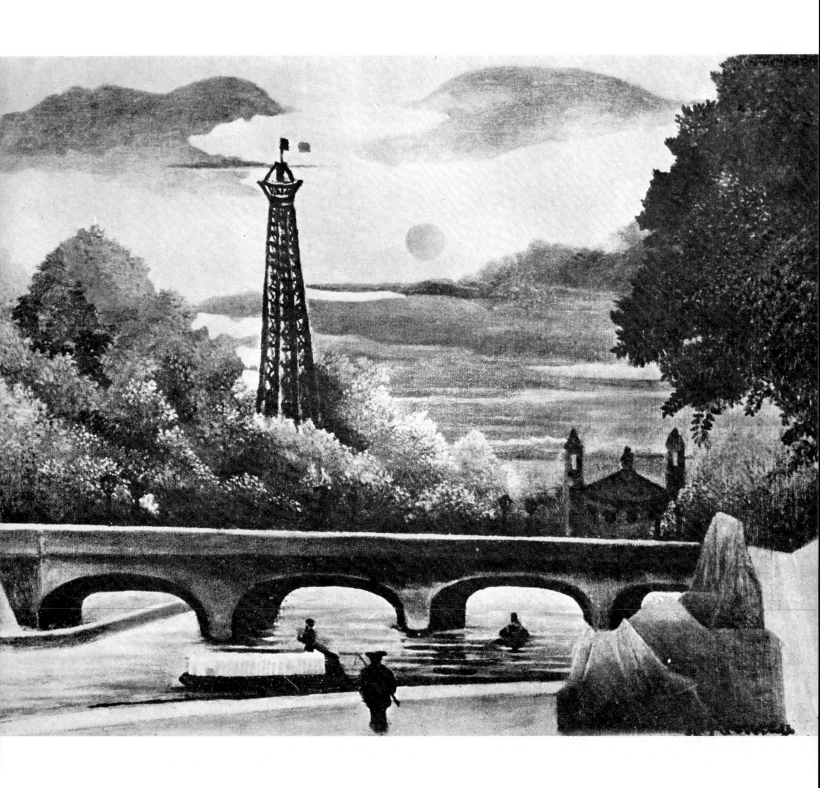

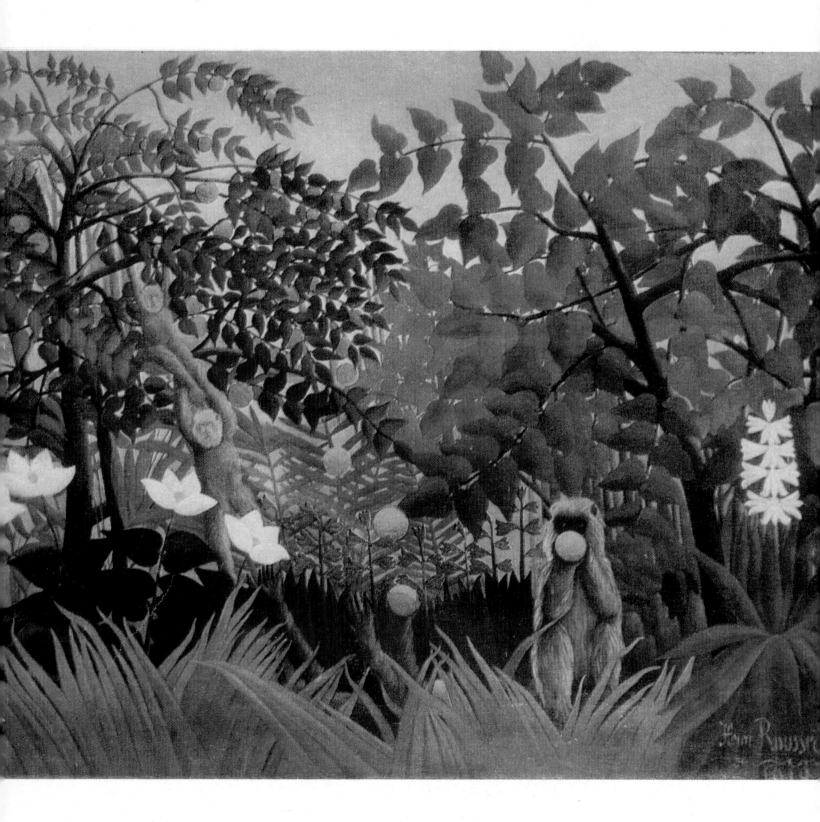

57. Horse Attacked by Jaguar

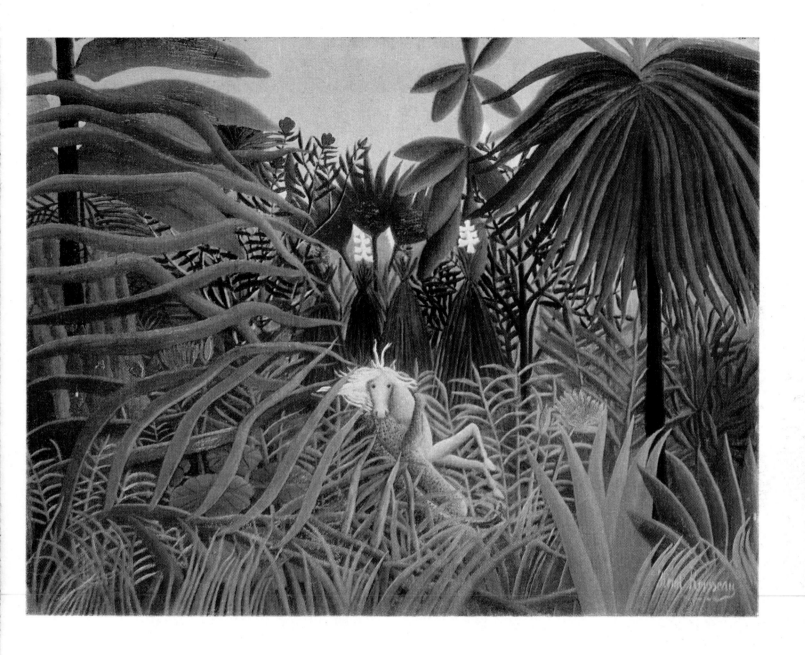

58. The Church of Notre-Dame
59. Muse Inspiring the Poet *(second version)*

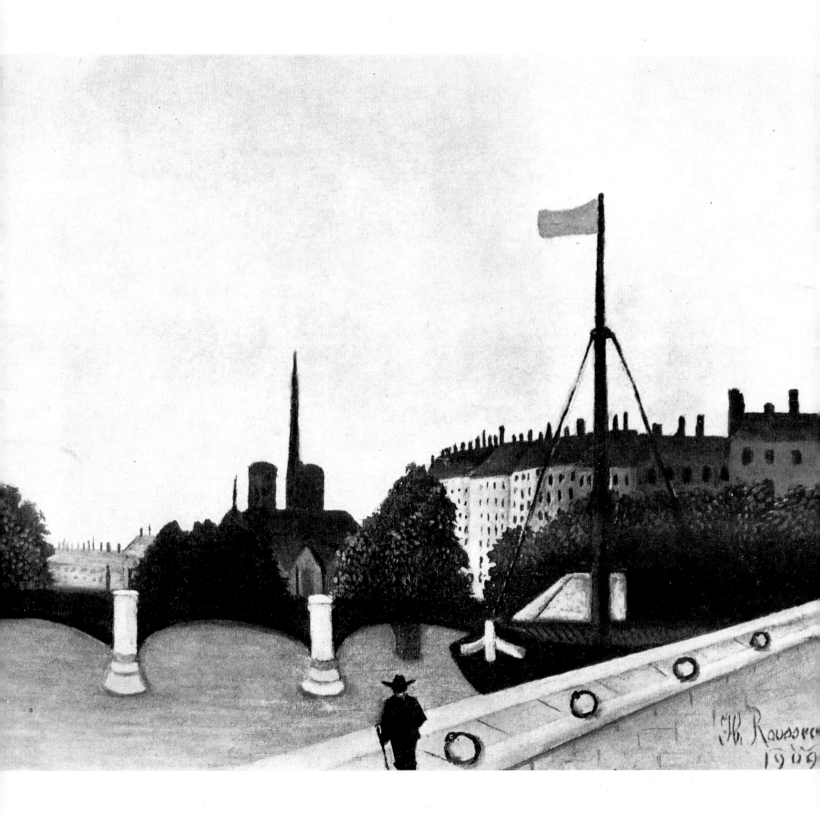

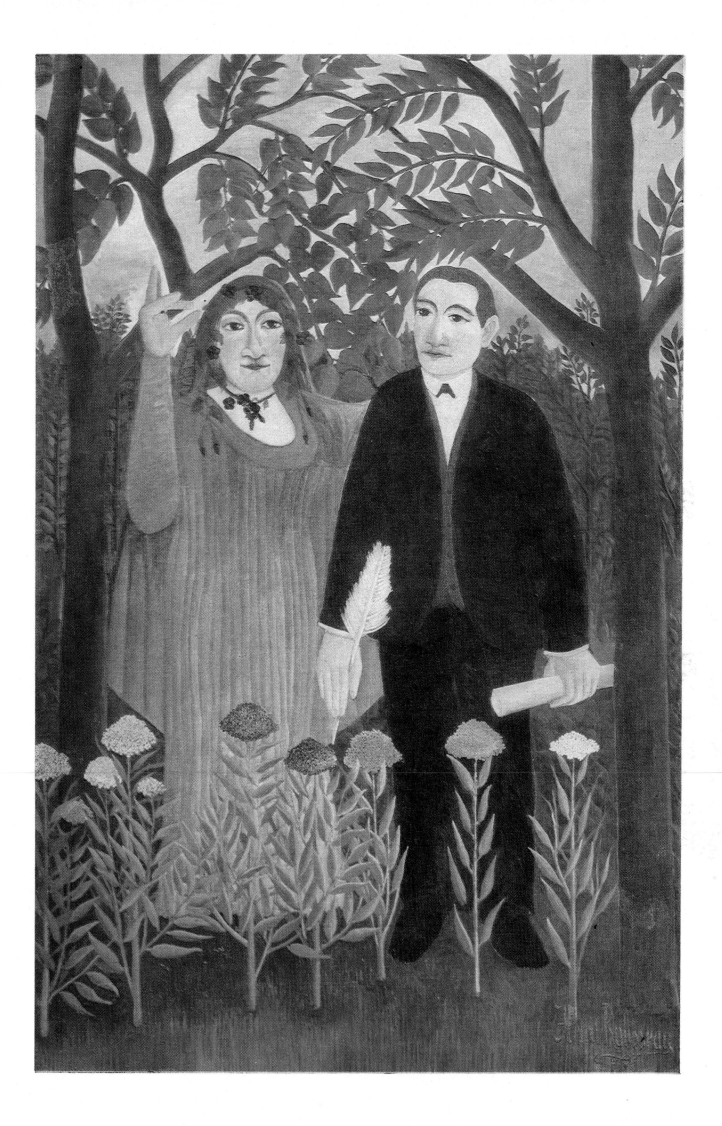

MERIDIANE PUBLISHING HOUSE
BUCHAREST

PRINTED IN ROMANIA